W. SEEING

A book made by
**John Berger, Sven Blomberg, Chris Fox,
Michael Dibb, Richard Hollis**

WAYS OF SEEING

based on the BBC television series with
JOHN BERGER

**British Broadcasting Corporation
and Penguin Books**

Published by the British Broadcasting Corporation, 35 Marylebone High Street, London, W1M 4AA

ISBN 978 0 563 122449

and by

PENGUIN BOOKS

Published by the Penguin Group
Penguin Books Ltd, One Embassy Gardens, 8 Viaduct Gardens, London, SW11 7BW, England
Penguin Group (USA) Inc., 375 Hudson Street, New York, New York 10014, USA
Penguin Group (Canada), 90 Eglinton Avenue East, Suite 700, Toronto, Ontario, Canada M4P 2Y3
(a division of Pearson Penguin Canada Inc.)
Penguin Ireland, 25 St Stephen's Green, Dublin 2, Ireland (a division of Penguin Books Ltd)
Penguin Group (Australia), 707 Collins Street, Melbourne, Victoria 3008, Australia
(a division of Pearson Australia Group Pty Ltd)
Penguin Books India Pvt Ltd, 11 Community Centre, Panchsheel Park, New Delhi - 110 017, India
Penguin Group (NZ), 67 Apollo Drive, Rosedale, Auckland 0632, New Zealand
(a division of Pearson New Zealand Ltd)
Penguin Books (South Africa) (Pty) Ltd, Block D, Rosebank Office Park, 181 Jan Smuts Avenue,
Parktown North, Gauteng 2193, South Africa

Penguin Books Ltd, Registered Offices: One Embassy Gardens, 8 Viaduct Gardens, London, SW11 7BW, England

www.penguin.com

ISBN 978 0 14 013515 2

First published in Great Britain by the British Broadcasting Corporation and Penguin Books Ltd 1972
54

First published in the United States of America by The Viking Press (A Richard Seaver Book) 1973
Published in Penguin Books in the United States of America 1977

Copyright in all countries of the International Copyright Union 1972 by Penguin Books Ltd
All rights reserved

Printed in China
Set in Monophoto Univers

Note to the reader

This book has been made by five of us. Our starting point was some of the ideas contained in the television series Ways of Seeing. We have tried to extend and elaborate these ideas. They have influenced not only what we say but also how we have set about trying to say it. The form of the book is as much to do with our purpose as the arguments contained within it.

The book consists of seven numbered essays. They can be read in any order. Four of the essays use words and images, three of them use only images. These purely pictorial essays (on ways of seeing women and on various contradictory aspects of the tradition of the oil painting) are intended to raise as many questions as the verbal essays. Sometimes in the pictorial essays no information at all is given about the images reproduced because it seemed to us that such information might distract from the points being made. In all cases, however, this information can be found in the List of Works Reproduced which is printed at the end of the book.

None of the essays pretends to deal with more than certain aspects of each subject: particularly those aspects thrown into relief by a modern historical consciousness. Our principal aim has been to start a process of questioning.

1

Seeing comes before words. The child looks and recognizes before it can speak.

But there is also another sense in which seeing comes before words. It is seeing which establishes our place in the surrounding world; we explain that world with words, but words can never undo the fact that we are surrounded by it. The relation between what we see and what we know is never settled. Each evening we *see* the sun set. We *know* that the earth is turning away from it. Yet the knowledge, the explanation, never quite fits the sight. The Surrealist painter Magritte commented on this always-present gap between words and seeing in a painting called The Key of Dreams.

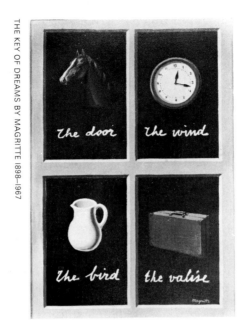

The way we see things is affected by what we know or what we believe. In the Middle Ages when men believed in the physical existence of Hell the sight of fire must have meant something different from what it means today. Nevertheless their idea of Hell owed a lot to the sight of fire consuming and the ashes remaining – as well as to their experience of the pain of burns.

When in love, the sight of the beloved has a completeness which no words and no embrace can match : a completeness which only the act of making love can temporarily accommodate.

Yet this seeing which comes before words, and can never be quite covered by them, is not a question of mechanically reacting to stimuli. (It can only be thought of in this way if one isolates the small part of the process which concerns the eye's retina.) We only see what we look at. To look is an act of choice. As a result of this act, what we see is brought within our reach – though not necessarily within arm's reach. To touch something is to situate oneself in relation to it. (Close your eyes, move round the room and

8

notice how the faculty of touch is like a static, limited form of sight.) We never look at just one thing; we are always looking at the relation between things and ourselves. Our vision is continually active, continually moving, continually holding things in a circle around itself, constituting what is present to us as we are.

Soon after we can see, we are aware that we can also be seen. The eye of the other combines with our own eye to make it fully credible that we are part of the visible world.

If we accept that we can see that hill over there, we propose that from that hill we can be seen. The reciprocal nature of vision is more fundamental than that of spoken dialogue. And often dialogue is an attempt to verbalize this — an attempt to explain how, either metaphorically or literally, 'you see things', and an attempt to discover how 'he sees things'.

In the sense in which we use the word in this book, all images are man-made.

An image is a sight which has been recreated or reproduced. It is an appearance, or a set of appearances, which has been detached from the place and time

in which it first made its appearance and preserved – for a few moments or a few centuries. Every image embodies a way of seeing. Even a photograph. For photographs are not, as is often assumed, a mechanical record. Every time we look at a photograph, we are aware, however slightly, of the photographer selecting that sight from an infinity of other possible sights. This is true even in the most casual family snapshot. The photographer's way of seeing is reflected in his choice of subject. The painter's way of seeing is reconstituted by the marks he makes on the canvas or paper. Yet, although every image embodies a way of seeing, our perception or appreciation of an image depends also upon our own way of seeing. (It may be, for example, that Sheila is one figure among twenty; but for our own reasons she is the one we have eyes for.)

Images were first made to conjure up the appearances of something that was absent. Gradually it became evident that an image could outlast what it represented; it then showed how something or somebody had once looked – and thus by implication how the subject had once been seen by other people. Later still the specific vision of the image-maker was also recognized as part of the record. An image became a record of how X had seen Y. This was the result of an increasing consciousness of individuality, accompanying an increasing awareness of history. It would be rash to try to date this last development precisely. But certainly in Europe such consciousness has existed since the beginning of the Renaissance.

No other kind of relic or text from the past can offer such a direct testimony about the world which surrounded other people at other times. In this respect images are more precise and richer than literature. To say this is not to deny the expressive or imaginative quality of art, treating it as mere documentary evidence; the more imaginative the work, the more profoundly it allows us to share the artist's experience of the visible.

Yet when an image is presented as a work of art, the way people look at it is affected by a whole series of learnt assumptions about art. Assumptions concerning:

Beauty
Truth
Genius
Civilization
Form
Status
Taste, etc.

Many of these assumptions no longer accord with the world as it is. (The world-as-it-is is more than pure objective fact, it includes consciousness.) Out of true with the present, these assumptions obscure the past. They mystify rather than clarify. The past is never there waiting to be discovered, to be recognized for exactly what it is. History always constitutes the relation between a present and its past. Consequently fear of the present leads to mystification of the past. The past is not for living in; it is a well of conclusions from which we draw in order to act. Cultural mystification of the past entails a double loss. Works of art are made unnecessarily remote. And the past offers us fewer conclusions to complete in action.

When we 'see' a landscape, we situate ourselves in it. If we 'saw' the art of the past, we would situate ourselves in history. When we are prevented from seeing it, we are being deprived of the history which belongs to us. Who benefits from this deprivation? In the end, the art of the past is being mystified because a privileged minority is striving to invent a history which can retrospectively justify the role of the ruling classes, and such a justification can no longer make sense in modern terms. And so, inevitably, it mystifies.

Let us consider a typical example of such mystification. A two-volume study was recently published on Frans Hals.* It is the authoritative work to date on this painter. As a book of specialized art history it is no better and no worse than the average.

* Seymour Slive, Frans Hals (Phaidon, London)

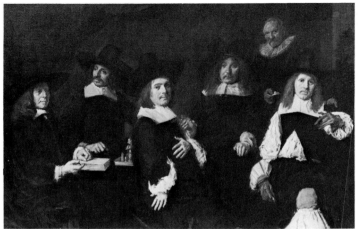

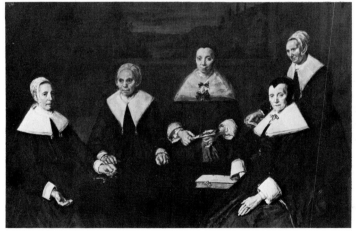

The last two great paintings by Frans Hals portray the Governors and the Governesses of an Alms House for old paupers in the Dutch seventeenth-century city of Haarlem. They were officially commissioned portraits. Hals, an old man

of over eighty, was destitute. Most of his life he had been in debt. During the winter of 1664, the year he began painting these pictures, he obtained three loads of peat on public charity, otherwise he would have frozen to death. Those who now sat for him were administrators of such public charity.

The author records these facts and then explicitly says that it would be incorrect to read into the paintings any criticism of the sitters. There is no evidence, he says, that Hals painted them in a spirit of bitterness. The author considers them, however, remarkable works of art and explains why. Here he writes of the Regentesses:

> Each woman speaks to us of the human condition with equal importance. Each woman stands out with equal clarity against the *enormous* dark surface, yet they are linked by a firm rhythmical arrangement and the subdued diagonal pattern formed by their heads and hands. Subtle modulations of the *deep*, glowing blacks contribute to the *harmonious fusion* of the whole and form an *unforgettable contrast* with the *powerful* whites and vivid flesh tones where the detached strokes reach *a peak of breadth and strength*. (our italics)

The compositional unity of a painting contributes fundamentally to the power of its image. It is reasonable to consider a painting's composition. But here the composition is written about as though it were in itself the emotional charge of the painting. Terms like harmonious fusion, unforgettable contrast, **reaching** a peak of breadth and strength transfer the emotion provoked by the image from the plane of lived experience, to that of disinterested 'art appreciation'. All conflict disappears. One is left with the unchanging 'human condition', and the painting considered as a marvellously made object.

Very little is known about Hals or the Regents who commissioned him. It is not possible to produce circumstantial evidence to establish what their relations were. But there is the evidence of the paintings themselves: the evidence of a group of men and a group of women as seen by another man, the painter. Study this evidence and judge for yourself.

The art historian fears such direct judgement:

As in so many other pictures by Hals, the penetrating
characterizations almost seduce us into believing that we
know the personality traits and even the habits of the
men and women portrayed.

**What is this 'seduction' he writes of? It is
nothing less than the paintings working upon us. They work
upon us because we accept the way Hals saw his sitters. We
do not accept this innocently. We accept it in so far as it
corresponds to our own observation of people, gestures, faces,
institutions. This is possible because we still live in a society
of comparable social relations and moral values. And it is
precisely this which gives the paintings their psychological and
social urgency. It is this – not the painter's skill as a 'seducer'
– which convinces us that we _can_ know the people portrayed.
The author continues:**

In the case of some critics the seduction has been a
total success. It has, for example, been asserted that
the Regent in the tipped slouch hat, which hardly covers
any of his long, lank hair, and whose curiously set
eyes do not focus, was shown in a drunken state.

This, he suggests, is a libel. He argues that it was a fashion at that time to wear hats on the side of the head. He cites medical opinion to prove that the Regent's expression could well be the result of a facial paralysis. He insists that the painting would have been unacceptable to the Regents if one of them had been portrayed drunk. One might go on discussing each of these points for pages. (Men in seventeenth-century Holland wore their hats on the side of their heads in order to be thought of as adventurous and pleasure-loving. Heavy drinking was an approved practice. Etcetera.) But such a discussion would take us even farther away from the only confrontation which matters and which the author is determined to evade.

In this confrontation the Regents and Regentesses stare at Hals, a destitute old painter who has lost his reputation and lives off public charity; he examines them through the eyes of a pauper who must nevertheless try to be objective, i.e., must try to surmount the way he sees as a pauper. This is the drama of these paintings. A drama of an 'unforgettable contrast'.

Mystification has little to do with the vocabulary used. Mystification is the process of explaining

away what might otherwise be evident. Hals was the first portraitist to paint the new characters and expressions created by capitalism. He did in pictorial terms what Balzac did two centuries later in literature. Yet the author of the authoritative work on these paintings sums up the artist's achievement by referring to

> Hals's unwavering commitment to his personal vision, which enriches our consciousness of our fellow men and heightens our awe for the ever-increasing power of the mighty impulses that enabled him to give us a close view of life's vital forces.

That is mystification.

In order to avoid mystifying the past (which can equally well suffer pseudo-Marxist mystification) let us now examine the particular relation which now exists, so far as pictorial images are concerned, between the present and the past. If we can see the present clearly enough, we shall ask the right questions of the past.

Today we see the art of the past as nobody saw it before. We actually perceive it in a different way.

This difference can be illustrated in terms of what was thought of as perspective. The convention of perspective, which is unique to European art and which was first established in the early Renaissance, centres everything on the eye of the beholder. It is like a beam from a lighthouse – only instead of light travelling outwards, appearances travel in. The conventions called those appearances *reality*. **Perspective makes the single eye the centre of the visible world. Everything converges on to the eye as to the vanishing point of infinity. The visible world is arranged for the spectator as the universe was once thought to be arranged for God.**

According to the convention of perspective there is no visual reciprocity. There is no need for God to situate himself in relation to others: he is himself the situation. The inherent contradiction in perspective was that it structured all images of reality to address a single spectator who, unlike God, could only be in one place at a time.

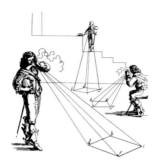

After the invention of the camera this contradiction gradually became apparent.

STILL FROM MAN WITH A MOVIE CAMERA BY VERTOV

* This quotation is from an article written in 1923 by Dziga Vertov, the revolutionary Soviet film director

I'm an eye. A mechanical eye. I, the machine, show you a world the way only I can see it. I free myself for today and forever from human immobility. I'm in constant movement. I approach and pull away from objects. I creep under them. I move alongside a running horse's mouth. I fall and rise with the falling and rising bodies. This is I, the machine, manoeuvring in the chaotic movements, recording one movement after another in the most complex combinations.

Freed from the boundaries of time and space, I co-ordinate any and all points of the universe, wherever I want them to be. My way leads towards the creation of a fresh perception of the world. Thus I explain in a new way the world unknown to you.*

The camera isolated momentary appearances and in so doing destroyed the idea that images were timeless. Or, to put it another way, the camera showed that the notion of time passing was inseparable from the experience of the visual (except in paintings). What you saw depended upon where you were when. What you saw was relative to your position in time and space. It was no longer possible to imagine everything converging on the human eye as on the vanishing point of infinity.

This is not to say that before the invention of the camera men believed that everyone could see everything. But perspective organized the visual field as though that were indeed the ideal. Every drawing or painting that used perspective proposed to the spectator that he was the unique centre of the world. The camera – and more particularly the movie camera – demonstrated that there was no centre.

The invention of the camera changed the way men saw. The visible came to mean something different to them. This was immediately reflected in painting.

For the Impressionists the visible no longer presented itself to man in order to be seen. On the contrary, the visible, in continual flux, became fugitive. For the Cubists the visible was no longer what confronted the single eye, but the totality of possible views taken from points all round the object (or person) being depicted.

STILL LIFE WITH WICKER CHAIR BY PICASSO 1881–

The invention of the camera also changed the way in which men saw paintings painted long before the camera was invented. Originally paintings were an integral part of the building for which they were designed. Sometimes in an early Renaissance church or chapel one has the feeling that the images on the wall are records of the building's interior life, that together they make up the building's memory – so much are they part of the particularity of the building.

CHURCH OF ST FRANCIS AT ASSISI

The uniqueness of every painting was once part of the uniqueness of the place where it resided. Sometimes the painting was transportable. But it could never be seen in two places at the same time. When the camera reproduces a painting, it destroys the uniqueness of its image. As a result its meaning changes. Or, more exactly, its meaning multiplies and fragments into many meanings.

This is vividly illustrated by what happens when a painting is shown on a television screen. The painting enters each viewer's house. There it is surrounded by his wallpaper, his furniture, his mementoes. It enters the atmosphere of his

19

family. It becomes their talking point. It lends its meaning to their meaning. At the same time it enters a million other houses and, in each of them, is seen in a different context. Because of the camera, the painting now travels to the spectator rather than the spectator to the painting. In its travels, its meaning is diversified.

One might argue that all reproductions more or less distort, and that therefore the original painting is still in a sense unique. Here is a reproduction of the Virgin of the Rocks by Leonardo da Vinci.

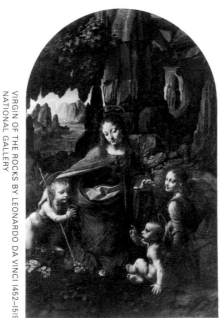

VIRGIN OF THE ROCKS BY LEONARDO DA VINCI 1452–1519
NATIONAL GALLERY

Having seen this reproduction, one can go to the National Gallery to look at the original and there discover what the reproduction lacks. Alternatively one can forget about the quality of the reproduction and simply be reminded, when one sees the original, that it is a famous painting of which somewhere one has already seen a reproduction. But in either case the uniqueness of the original now lies in it being *the original of a reproduction*. It is no longer what its image shows that strikes one as unique; its first meaning is no longer to be found in what it says, but in what it is.

This new status of the original work is the perfectly rational consequence of the new means of reproduction. But it is at this point that a process of mystification again enters. The meaning of the original work no longer lies in what it uniquely says but in what it uniquely is. How is its unique existence evaluated and defined in our present culture? It is defined as an object whose value depends upon its rarity. This value is affirmed and gauged by the price it fetches on the market. But because it is nevertheless 'a work of art' — and art is thought to be greater than commerce — its market price is said to be a reflection of its spiritual value. Yet the spiritual value of an object, as distinct from a message or an example, can only be explained in terms of magic or religion. And since in modern society neither of these is a living force, the art object, the 'work of art', is enveloped in an atmosphere of entirely bogus religiosity. Works of art are discussed and presented as though they were holy relics: relics which are first and foremost evidence of their own survival. The past in which they originated is studied in order to prove their survival genuine. They are declared art when their line of descent can be certified.

Before the Virgin of the Rocks the visitor to the National Gallery would be encouraged by nearly everything he might have heard and read about the painting to feel something like this: 'I am in front of it. I can see it. This painting by Leonardo is unlike any other in the world. The National Gallery has the real one. If I look at this painting hard enough, I should somehow be able to feel its authenticity. The Virgin of the Rocks by Leonardo da Vinci: it is authentic and therefore it is beautiful.'

To dismiss such feelings as naïve would be quite wrong. They accord perfectly with the sophisticated culture of art experts for whom the National Gallery catalogue is written. The entry on the Virgin of the Rocks is one of the longest entries. It consists of fourteen closely printed pages. They do not deal with the meaning of the image. They deal with who commissioned the painting, legal squabbles, who owned it, its likely date, the families of its owners. Behind this information lie years of research. The aim of the research is to prove beyond any shadow of doubt that the painting is a genuine Leonardo. The secondary aim is to prove that an almost identical painting in the Louvre is a replica of the National Gallery version.

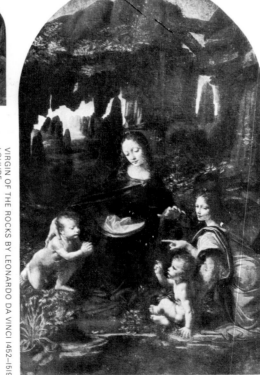

NATIONAL GALLERY

VIRGIN OF THE ROCKS BY LEONARDO DA VINCI 1452–1519
LOUVRE

French art historians try to prove the opposite.

The National Gallery sells more reproductions of **Leonardo's cartoon of** The Virgin and Child with St Anne and St John the Baptist **than any other picture in their collection. A few years ago it was known only to scholars. It became famous because an American wanted to buy it for two and a half million pounds.**

Now it hangs in a room by itself. The room is like a chapel. The drawing is behind bullet-proof perspex. It has acquired a new kind of impressiveness. Not because of what it shows – not because of the meaning of its image. It has become impressive, mysterious, because of its market value.

The bogus religiosity which now surrounds original works of art, and which is ultimately dependent upon their market value, has become the substitute for what paintings lost when the camera made them reproducible. Its function is nostalgic. It is the final empty claim for the continuing values of an oligarchic, undemocratic culture. If the image is no longer unique and exclusive, the art object, the thing, must be made mysteriously so.

The majority of the population do not visit art museums. The following table shows how closely an interest in art is related to privileged education.

National proportion of art museum visitors according to level of education: Percentage of each educational category who visit art museums

	Greece	Poland	France	Holland		Greece	Poland	France	Holland
With no educational qualification	0.02	0.12	0.15	—	Only secondary education	10.5	10.4	10	20
Only primary education	0.30	1.50	0.45	0.50	Further and higher education	11.5	11.7	12.5	17.3

Source: Pierre Bourdieu and Alain Darbel, *L'Amour de l'Art*, Editions de Minuit, Paris 1969, Appendix 5, table 4

The majority take it as axiomatic that the museums are full of holy relics which refer to a mystery which excludes them: the mystery of unaccountable wealth. Or, to put this another way, they believe that original masterpieces belong to the preserve (both materially and spiritually) of the rich. Another table indicates what the idea of an art gallery suggests to each social class.

Of the places listed below which does a museum remind you of most?

	Manual workers	Skilled and white collar workers	Professional and upper managerial
	%	%	%
Church	66	45	30.5
Library	9	34	28
Lecture hall	—	4	4.5
Department store or entrance hall in public building	—	7	2
Church and library	9	2	4.5
Church and lecture hall	4	2	—
Library and lecture hall	—	—	2
None of these	4	2	19.5
No reply	8	4	9
	100 (n = 53)	100 (n = 98)	100 (n = 99)

Source: as above, appendix 4, table 8

In the age of pictorial reproduction the meaning of paintings is no longer attached to them; their meaning becomes transmittable: that is to say it becomes information of a sort, and, like all information, it is either put to use or ignored; information carries no special authority within itself. When a painting is put to use, its meaning is either modified or totally changed. One should be quite clear about what this involves. It is not a question of reproduction failing to

reproduce certain aspects of an image faithfully; it is a question of reproduction making it possible, even inevitable, that an image will be used for many different purposes and that the reproduced image, unlike an original work, can lend itself to them all. Let us examine some of the ways in which the reproduced image lends itself to such usage.

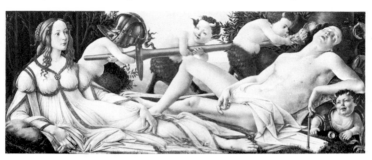

Reproduction isolates a detail of a painting from the whole. The detail is transformed. An allegorical figure becomes a portrait of a girl.

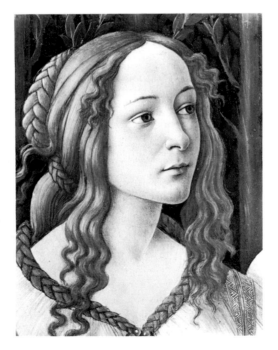

When a painting is reproduced by a film camera it inevitably becomes material for the film-maker's argument.

A film which reproduces images of a painting leads the spectator, through the painting, to the film-maker's own conclusions. The painting lends authority to the film-maker.

This is because a film unfolds in time and a painting does not.

In a film the way one image follows another, their succession, constructs an argument which becomes irreversible.

In a painting all its elements are there to be seen simultaneously. The spectator may need time to examine each element of the painting but whenever he reaches a conclusion, the simultaneity of the whole painting is there to reverse or qualify his conclusion. The painting maintains its own authority.

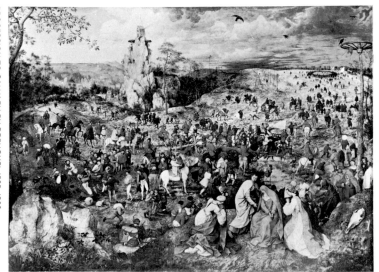

Paintings are often reproduced with words around them.

This is a landscape of a cornfield with birds flying out of it. Look at it for a moment. Then turn the page.

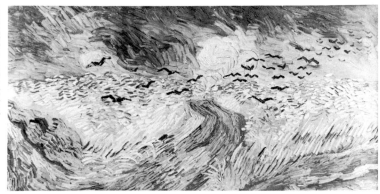

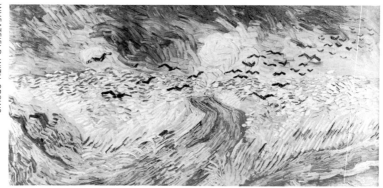

This is the last picture that Van Gogh painted before he killed himself.

It is hard to define exactly how the words have changed the image but undoubtedly they have. The image now illustrates the sentence.

In this essay each image reproduced has become part of an argument which has little or nothing to do with the painting's original independent meaning. The words have quoted the paintings to confirm their own verbal authority. (The essays without words in this book may make that distinction clearer.)

Reproduced paintings, like all information, have to hold their own against all the other information being continually transmitted.

Consequently a reproduction, as well as making its own references to the image of its original, becomes itself the reference point for other images. The meaning of an image is changed according to what one sees immediately beside it or what comes immediately after it. Such authority as it retains, is distributed over the whole context in which it appears.

EVERY JACKET CARRIES A GOVERNMENT HEALTH WARNING.

If women knew then... what they know now.

Because works of art are reproducible, they can, theoretically, be used by anybody. Yet mostly — in art books, magazines, films or within gilt frames in living-rooms — reproductions are still used to bolster the illusion that nothing has changed, that art, with its unique undiminished authority, justifies most other forms of authority, that art makes inequality seem noble and hierarchies seem thrilling. For example, the whole concept of the National Cultural Heritage exploits the authority of art to glorify the present social system and its priorities.

The means of reproduction are used politically and commercially to disguise or deny what their existence makes possible. But sometimes individuals use them differently.

Adults and children sometimes have boards in their bedrooms or living-rooms on which they pin pieces of paper: letters, snapshots, reproductions of paintings, newspaper cuttings, original drawings, postcards. On each board all the images belong to the same language and all are more or less equal within it, because they have been chosen in a highly personal way to match and express the experience of the room's inhabitant. Logically, these boards should replace museums.

What are we saying by that? Let us first be sure about what we are not saying.

We are not saying that there is nothing left to experience before original works of art except a sense of awe because they have survived. The way original works of art are usually approached – through museum catalogues, guides, hired cassettes, etc. – is not the only way they might be approached. When the art of the past ceases to be viewed nostalgically, the works will cease to be holy relics – although they will never re-become what they were before the age of reproduction. We are not saying original works of art are now useless.

Original paintings are silent and still in a sense
that information never is. Even a reproduction hung on a wall
is not comparable in this respect for in the original the silence
and stillness permeate the actual material, the paint, in which
one follows the traces of the painter's immediate gestures.
This has the effect of closing the distance in time between the
painting of the picture and one's own act of looking at it. In
this special sense all paintings are contemporary. Hence the
immediacy of their testimony. Their historical moment is
literally there before our eyes. Cézanne made a similar
observation from the painter's point of view. 'A minute in the
world's life passes! To paint it in its reality, and forget
everything for that! To become that minute, to be the
sensitive plate . . . give the image of what we see, forgetting
everything that has appeared before our time . . .' What we
make of that painted moment when it is before our eyes
depends upon what we expect of art, and that in turn depends
today upon how we have already experienced the meaning of
paintings through reproductions.

31

Nor are we saying that all art can be understood spontaneously. We are not claiming that to cut out a magazine reproduction of an archaic Greek head, because it is reminiscent of some personal experience, and to pin it on to a board beside other disparate images, is to come to terms with the full meaning of that head.

The idea of innocence faces two ways. By refusing to enter a conspiracy, one remains innocent of that conspiracy. But to remain innocent may also be to remain ignorant. The issue is not between innocence and knowledge (or between the natural and the cultural) but between a total approach to art which attempts to relate it to every aspect of experience and the esoteric approach of a few specialized experts who are the clerks of the nostalgia of a ruling class in decline. (In decline, not before the proletariat, but before the new power of the corporation and the state.) The real question is: to whom does the meaning of the art of the past properly belong? To those who can apply it to their own lives, or to a cultural hierarchy of relic specialists?

The visual arts have always existed within a certain preserve; originally this preserve was magical or sacred. But it was also physical: it was the place, the cave, the building, in which, or for which, the work was made. The experience of art, which at first was the experience of ritual, was set apart from the rest of life — precisely in order to be able to exercise power over it. Later the preserve of art became a social one. It entered the culture of the ruling class, whilst physically it was set apart and isolated in their palaces and houses. During all this history the authority of art was inseparable from the particular authority of the preserve.

What the modern means of reproduction have done is to destroy the authority of art and to remove it — or, rather, to remove its images which they reproduce — from any preserve. For the first time ever, images of art have become ephemeral, ubiquitous, insubstantial, available, valueless, free. They surround us in the same way as a language surrounds us. They have entered the mainstream of life over which they no longer, in themselves, have power.

Yet very few people are aware of what has happened because the means of reproduction are used nearly

all the time to promote the illusion that nothing has changed except that the masses, thanks to reproductions, can now begin to appreciate art as the cultured minority once did. Understandably, the masses remain uninterested and sceptical.

If the new language of images were used differently, it would, through its use, confer a new kind of power. Within it we could begin to define our experiences more precisely in areas where words are inadequate. (Seeing comes before words.) Not only personal experience, but also the essential historical experience of our relation to the past: that is to say the experience of seeking to give meaning to our lives, of trying to understand the history of which we can become the active agents.

The art of the past no longer exists as it once did. Its authority is lost. In its place there is a language of images. What matters now is who uses that language for what purpose. This touches upon questions of copyright for reproduction, the ownership of art presses and publishers, the total policy of public art galleries and museums. As usually presented, these are narrow professional matters. One of the aims of this essay has been to show that what is really at stake is much larger. A people or a class which is cut off from its own past is far less free to choose and to act as a people or class than one that has been able to situate itself in history. This is why – and this is the only reason why – the entire art of the past has now become a political issue.

Many of the ideas in the preceding essay have been taken from another, written over forty years ago by the German critic and philosopher Walter Benjamin.

His essay was entitled The Work of Art in the Age of Mechanical Reproduction. **This essay is available in English in a collection called** Illuminations **(Cape, London 1970).**

2

36

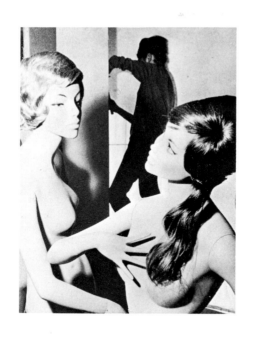

LA ROBE
A TENU BON,
LE SOURIRE
AUSSI

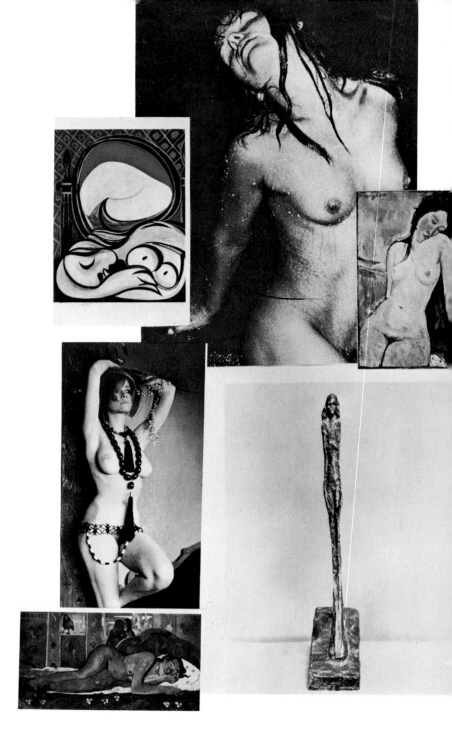

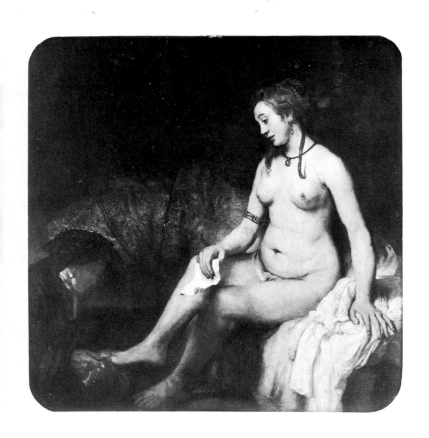

New Ladder-Stops give up to 25% more wear even in your sheerest seamfree stockings

Almay's new lipsticks are a blaze of frosted colour.

But that's only half the story.

Beautiful pearly lipsticks, but something more. Delicate lips can dry out and crack under a lipstick that does not moisturise. So Almay put in rich moisturisers to keep your lips soft and smooth. These brilliant frosted lipsticks in 10 glowing glistening colours give you tantalising lips that even be beautiful and Almay call them Colour Moist Pearls. Like everything Almay makes they are hypo-allergenic. That is the full story.

ALMAY
Hypo-allergenic Cosmetics

Take a sensitive English skin, cover it with Cooltan, lay under the sun, and turn slowly until golden brown.

English skin is fair and sensitive. So when it comes face to face with the sun it burns more easily than it tans.

Fortunately, Cooltan is made specially to protect the English skin on holiday.

It has a stronger screening agent to protect you from the harsh rays of the sun. So you turn brown, not red. It keeps your skin soft and moist. So you don't peel. And when things hot up, especially after sunbathing, Cooltan cools you down.

There are 3 kinds of Cooltan to choose from. Cream, oil and aerosol mousse. They'll protect your whole family - children too. So when you take everything off - put Cooltan on.

Cooltan for the English skin.

Frank Cooper puts everything he's got into making soup.

And our picture shows just some of the good things he's got. Also one of the soups–Duck with Orange. The others are: Cream of Pheasant, Cream of Scampi, Game, Hunter (Venison and Vegetables), and Turkey with Chestnut and Cranberry. All at a reasonable 2'11d. a tin.

Wolsey's Top 5
tights: for the
anti-panti pe

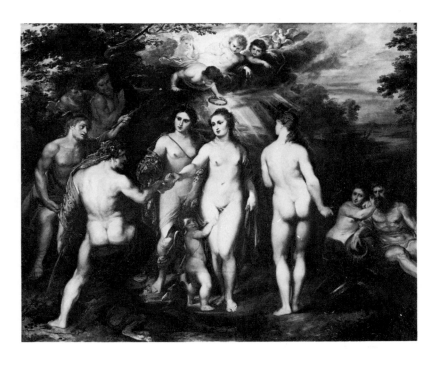

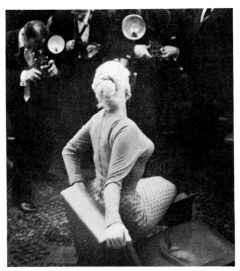

43

3

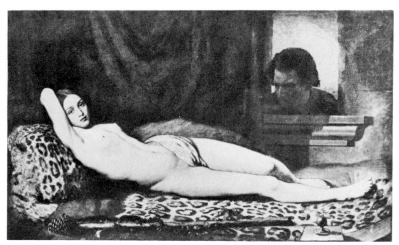

 According to usage and conventions which are at last being questioned but have by no means been overcome, the social presence of a woman is different in kind from that of a man. A man's presence is dependent upon the promise of power which he embodies. If the promise is large and credible his presence is striking. If it is small or incredible, he is found to have little presence. The promised power may be moral, physical, temperamental, economic, social, sexual – but its object is always exterior to the man. A man's presence

suggests what he is capable of doing to you or for you. His presence may be fabricated, in the sense that he pretends to be capable of what he is not. But the pretence is always towards a power which he exercises on others.

By contrast, a woman's presence expresses her own attitude to herself, and defines what can and cannot be done to her. Her presence is manifest in her gestures, voice, opinions, expressions, clothes, chosen surroundings, taste — indeed there is nothing she can do which does not contribute to her presence. Presence for a woman is so intrinsic to her person that men tend to think of it as an almost physical emanation, a kind of heat or smell or aura.

To be born a woman has been to be born, within an allotted and confined space, into the keeping of men. The social presence of women has developed as a result of their ingenuity in living under such tutelage within such a limited space. But this has been at the cost of a woman's self being split into two. A woman must continually watch herself. She is almost continually accompanied by her own image of herself. Whilst she is walking across a room or whilst she is weeping at the death of her father, she can scarcely avoid envisaging herself walking or weeping. From earliest childhood she has been taught and persuaded to survey herself continually.

And so she comes to consider the *surveyor* and the *surveyed* within her as the two constituent yet always distinct elements of her identity as a woman.

She has to survey everything she is and everything she does because how she appears to others, and ultimately how she appears to men, is of crucial importance for what is normally thought of as the success of her life. Her own sense of being in herself is supplanted by a sense of being appreciated as herself by another.

Men survey women before treating them. Consequently how a woman appears to a man can determine how she will be treated. To acquire some control over this process, women must contain it and interiorize it. That part of a woman's self which is the surveyor treats the part which is the surveyed so as to demonstrate to others how her whole self would like to be treated. And this exemplary treatment of herself by herself constitutes her presence. Every woman's

presence regulates what is and is not 'permissible' within her presence. Every one of her actions – whatever its direct purpose or motivation – is also read as an indication of how she would like to be treated. If a woman throws a glass on the floor, this is an example of how she treats her own emotion of anger and so of how she would wish it to be treated by others. If a man does the same, his action is only read as an expression of his anger. If a woman makes a good joke this is an example of how she treats the joker in herself and accordingly of how she as a joker-woman would like to be treated by others. Only a man can make a good joke for its own sake.

One might simplify this by saying: *men act* and *women appear*. Men look at women. Women watch themselves being looked at. This determines not only most relations between men and women but also the relation of women to themselves. The surveyor of woman in herself is male: the surveyed female. Thus she turns herself into an object – and most particularly an object of vision: a sight.

In one category of European oil painting women were the principal, ever-recurring subject. That category is the nude. In the nudes of European painting we can discover some of the criteria and conventions by which women have been seen and judged as sights.

The first nudes in the tradition depicted Adam and Eve. It is worth referring to the story as told in Genesis:

> And when the woman saw that the tree was good for food, and that it was a delight to the eyes, and that the tree was to be desired to make one wise, she took of the fruit thereof and did eat; and she gave also unto her husband with her, and he did eat.
>
> And the eyes of them both were opened, and they knew that they were naked; and they sewed fig-leaves together and made themselves aprons. . . . And the

47

Lord God called unto the man and said unto him, 'Where are thou?' And he said, 'I heard thy voice in the garden, and I was afraid, because I was naked; and I hid myself. . . .

Unto the woman God said, 'I will greatly multiply thy sorrow and thy conception; in sorrow thou shalt bring forth children; and thy desire shall be to thy husband and he shall rule over thee'.

What is striking about this story? They became aware of being naked because, as a result of eating the apple, each saw the other differently. Nakedness was created in the mind of the beholder.

The second striking fact is that the woman is blamed and is punished by being made subservient to the man. In relation to the woman, the man becomes the agent of God.

In the medieval tradition the story was often illustrated, scene following scene, as in a strip cartoon.

FALL AND EXPULSION FROM PARADISE
BY POL DE LIMBOURG. EARLY 15TH CENTURY

During the Renaissance the narrative sequence disappeared, and the single moment depicted became the moment of shame. The couple wear fig-leaves or make a modest gesture with their hands. But now their shame is not so much in relation to one another as to the spectator.

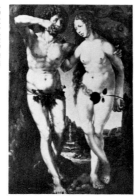

ADAM AND EVE BY MABUSE, EARLY 16TH CENTURY

Later the shame becomes a kind of display.

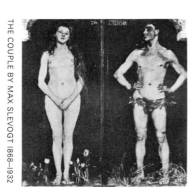

THE COUPLE BY MAX SLEVOGT 1868–1932

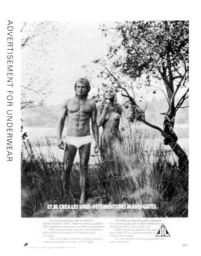

ADVERTISEMENT FOR UNDERWEAR

When the tradition of painting became more secular, other themes also offered the opportunity of painting nudes. But in them all there remains the implication that the subject (a woman) is aware of being seen by a spectator.

She is not naked as she is.
She is naked as the spectator sees her.

Often — as with the favourite subject of Susannah and the Elders — this is the actual theme of the picture. We join the Elders to spy on Susannah taking her bath. She looks back at us looking at her.

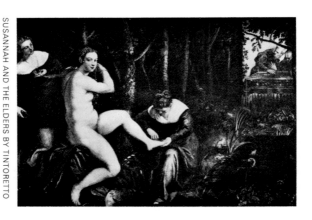

In another version of the subject by Tintoretto, Susannah is looking at herself in a mirror. Thus she joins the spectators of herself.

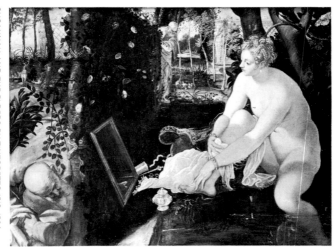

The mirror was often used as a symbol of the vanity of woman. The moralizing, however, was mostly hypocritical.

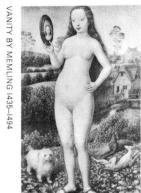

VANITY BY MEMLING 1435–1494

You painted a naked woman because you enjoyed looking at her, you put a mirror in her hand and you called the painting *Vanity*, thus morally condemning the woman whose nakedness you had depicted for your own pleasure.

The real function of the mirror was otherwise. It was to make the woman connive in treating herself as, first and foremost, a sight.

The Judgement of Paris was another theme with the same inwritten idea of a man or men looking at naked women.

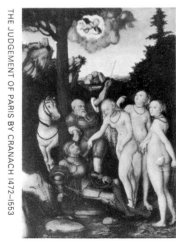

THE JUDGEMENT OF PARIS BY CRANACH 1472–1553

But a further element is now added. The element of judgement. Paris awards the apple to the woman he finds most beautiful. Thus Beauty becomes competitive. (Today The Judgement of Paris has become the Beauty Contest.) Those who are not judged beautiful are *not beautiful*. Those who are, are given the prize.

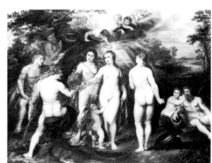

THE JUDGEMENT OF PARIS BY RUBENS 1577–1640

The prize is to be owned by a judge – that is to say to be available for him. Charles the Second commissioned a secret painting from Lely. It is a highly typical image of the tradition. Nominally it might be a Venus and Cupid. In fact it is a portrait of one of the King's mistresses, Nell Gwynne. It shows her passively looking at the spectator staring at her naked.

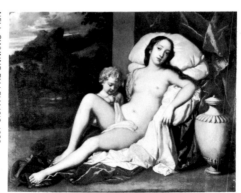

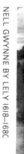
NELL GWYNNE BY LELY 1618–180C

This nakedness is not, however, an expression of her own feelings; it is a sign of her submission to the owner's feelings or demands. (The owner of both woman and painting.) The painting, when the King showed it to others, demonstrated this submission and his guests envied him.

It is worth noticing that in other non-European traditions – in Indian art, Persian art, African art, Pre-Columbian art – nakedness is never supine in this way. And if, in these traditions, the theme of a work is sexual attraction, it is likely to show active sexual love as between two people, the woman as active as the man, the actions of each absorbing the other.

We can now begin to see the difference between nakedness and nudity in the European tradition. In his book on The Nude **Kenneth Clark** maintains that to be naked is simply to be without clothes, whereas the nude is a form of art. According to him, a nude is not the starting point of a painting, but a way of seeing which the painting achieves. To some degree, this is true – although the way of seeing 'a nude' is not necessarily confined to art: there are also nude photographs, nude poses, nude gestures. What is true is that the nude is always conventionalized – and the authority for its conventions derives from a certain tradition of art.

What do these conventions mean? What does a nude signify? It is not sufficient to answer these questions merely in terms of the art-form, for it is quite clear that the nude also relates to lived sexuality.

To be naked is to be oneself.

To be nude is to be seen naked by others and yet not recognized for oneself. A naked body has to be seen as an object in order to become a nude. (The sight of it as an object stimulates the use of it as an object.) Nakedness reveals itself. Nudity is placed on display.

To be naked is to be without disguise.

To be on display is to have the surface of one's own skin, the hairs of one's own body, turned into a disguise which, in that situation, can never be discarded. The nude is condemned to never being naked. Nudity is a form of dress.

In the average European oil painting of the nude the principal protagonist is never painted. He is the spectator in front of the picture and he is presumed to be a man. Everything is addressed to him. Everything must appear to be the result of his being there. It is for him that the figures have assumed their nudity. But he, by definition, is a stranger — with his clothes still on.

Consider the Allegory of Time and Love by Bronzino.

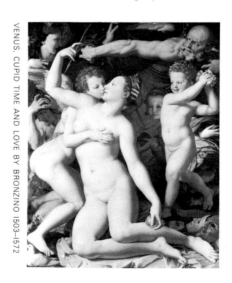

VENUS, CUPID TIME AND LOVE BY BRONZINO 1503–1572

The complicated symbolism which lies behind this painting need not concern us now because it does not affect its sexual appeal — at the first degree. Before it is anything else, this is a painting of sexual provocation.

The painting was sent as a present from the Grand Duke of Florence to the King of France. The boy kneeling on the cushion and kissing the woman is Cupid. She is Venus. But the way her body is arranged has nothing to do with their kissing. Her body is arranged in the way it is, to display it to the man looking at the picture. This picture is made to appeal to *his* sexuality. It has nothing to do with her sexuality. (Here and in the European tradition generally, the convention of not painting the hair on a woman's body helps towards the same end. Hair is associated with sexual power, with passion. The woman's sexual passion needs to be minimized so that the spectator may feel that he has the monopoly of such passion.) Women are there to feed an appetite, not to have any of their own.

Compare the expressions of these two women:

LA GRANDE ODALISQUE
BY INGRES 1780—1867

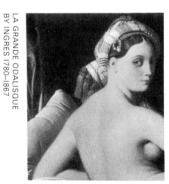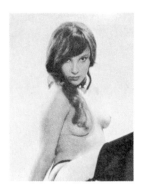

one the model for a famous painting by Ingres and the other a model for a photograph in a girlie magazine.

Is not the expression remarkably similar in each case? It is the expression of a woman responding with calculated charm to the man whom she imagines looking at her – although she doesn't know him. She is offering up her femininity as the surveyed.

It is true that sometimes a painting includes a male lover.

BACCHUS, CERES AND CUPID BY VON AACHEN 1552—1615

But the woman's attention is very rarely directed towards him. Often she looks away from him or she looks out of the picture towards the one who considers himself her true lover — the spectator-owner.

There was a special category of private pornographic paintings (especially in the eighteenth century) in which couples making love make an appearance. But even in front of these it is clear that the spectator-owner will in fantasy oust the other man, or else identify with him. By contrast the image of the couple in non-European traditions provokes the notion of many couples making love. 'We all have a thousand hands, a thousand feet and will never go alone.'

Almost all post-Renaissance European sexual imagery is frontal — either literally or metaphorically — because the sexual protagonist is the spectator-owner looking at it.

The absurdity of this male flattery reached its peak in the public academic art of the nineteenth century.

LES ORÉADES BY BOUGUEREAU 1825–1905

Men of state, of business, discussed under paintings like this. When one of them felt he had been outwitted, he looked up for consolation. What he saw reminded him that he was a man.

There are a few exceptional nudes in the European tradition of oil painting to which very little of what has been said above applies. Indeed they are no longer nudes — they break the norms of the art-form; they are paintings of loved women, more or less naked. Among the hundreds of thousands of nudes which make up the tradition there are perhaps a hundred of these exceptions. In each case the painter's personal vision of the particular women he is painting is so strong that it makes no allowance for the spectator. The painter's vision binds the woman to him so that they become as inseparable as couples in stone. The spectator

can witness their relationship — but he can do no more: he is
forced to recognize himself as the outsider he is. He cannot
deceive himself into believing that she is naked for him. He
cannot turn her into a nude. The way the painter has painted
her includes her will and her intentions in the very structure of
the image, in the very expression of her body and her face.

DANÄE BY REMBRANDT 1606–1669

The typical and the exceptional in the tradition
can be defined by the simple naked/nude antinomy, but the
problem of painting nakedness is not as simple as it might
at first appear.

What is the sexual function of nakedness in
reality? Clothes encumber contact and movement. But it would
seem that nakedness has a positive visual value in its own
right: we want to *see* the other naked: the other delivers to us
the sight of themselves and we seize upon it — sometimes
quite regardless of whether it is for the first time or the
hundredth. What does this sight of the other mean to us, how
does it, at that instant of total disclosure, affect our desire?

Their nakedness acts as a confirmation and provokes a very strong sense of relief. She is a woman like any other: or he is a man like any other: we are overwhelmed by the marvellous simplicity of the familiar sexual mechanism.

We did not, of course, consciously expect this to be otherwise: unconscious homosexual desires (or unconscious heterosexual desires if the couple concerned are homosexual) may have led each to half expect something different. But the 'relief' can be explained without recourse to the unconscious.

We did not expect them to be otherwise, but the urgency and complexity of our feelings bred a sense of uniqueness which the sight of the other, as she is or as he is, now dispels. They are more like the rest of their sex than they are different. In this revelation lies the warm and friendly – as opposed to cold and impersonal – anonymity of nakedness.

One could express this differently: at the moment of nakedness first perceived, an element of banality enters: an element that exists only because we need it.

Up to that instant the other was more or less mysterious. Etiquettes of modesty are not merely puritan or sentimental: it is reasonable to recognize a loss of mystery. And the explanation of this loss of mystery may be largely visual. The focus of perception shifts from eyes, mouth, shoulders, hands – all of which are capable of such subtleties of expression that the personality expressed by them is manifold – it shifts from these to the sexual parts, whose formation suggests an utterly compelling but single process. The other is reduced or elevated – whichever you prefer – to their primary sexual category: male or female. Our relief is the relief of finding an unquestionable reality to whose direct demands our earlier highly complex awareness must now yield.

We need the banality which we find in the first instant of disclosure because it grounds us in reality. But it does more than that. This reality, by promising the familiar, proverbial mechanism of sex, offers, at the same time, the possibility of the shared subjectivity of sex.

The loss of mystery occurs simultaneously with the offering of the means for creating a shared mystery. The sequence is: subjective – objective – subjective to the power of two.

We can now understand the difficulty of creating a static image of sexual nakedness. In lived sexual experience nakedness is a process rather than a state. If one moment of that process is isolated, its image will seem banal and its banality, instead of serving as a bridge between two intense imaginative states, will be chilling. This is one reason why expressive photographs of the naked are even rarer than paintings. The easy solution for the photographer is to turn the figure into a nude which, by generalizing both sight and viewer and making sexuality unspecific, turns desire into fantasy.

Let us examine an exceptional painted image of nakedness. It is a painting by Rubens of his young second wife whom he married when he himself was relatively old.

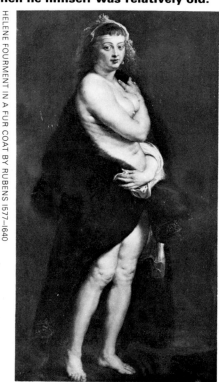

HELENE FOURMENT IN A FUR COAT BY RUBENS 1577–1640

We see her in the act of turning, her fur about to slip off her shoulders. Clearly she will not remain as she is for more than a second. In a superficial sense her image is as

instantaneous as a photograph's. But, in a more profound sense, the painting 'contains' time and its experience. It is easy to imagine that a moment ago before she pulled the fur round her shoulders, she was entirely naked. The consecutive stages up to and away from the moment of total disclosure have been transcended. She can belong to any or all of them simultaneously.

Her body confronts us, not as an immediate sight, but as experience – the painter's experience. Why? There are superficial anecdotal reasons: her dishevelled hair, the expression of her eyes directed towards him, the tenderness with which the exaggerated susceptibility of her skin has been painted. But the profound reason is a formal one. Her appearance has been literally re-cast by the painter's subjectivity. Beneath the fur that she holds across herself, the upper part of her body and her legs can never meet. There is a displacement sideways of about nine inches: her thighs, in order to join on to her hips, are at least nine inches too far to the left.

Rubens probably did not plan this: the spectator may not consciously notice it. In itself it is unimportant. What matters is what it permits. It permits the body to become impossibly dynamic. Its coherence is no longer within itself but within the experience of the painter. More precisely, it permits the upper and lower halves of the body to rotate separately, and in opposite directions, round the sexual centre which is hidden: the torso turning to the right, the legs to the left. At the same time this hidden sexual centre is connected by means of the dark fur coat to all the surrounding darkness in the picture, so that she is turning both around and within the dark which has been made a metaphor for her sex.

Apart from the necessity of transcending the single instant and of admitting subjectivity, there is, as we have seen, one further element which is essential for any great sexual image of the naked. This is the element of banality which must be undisguised but not chilling. It is this which distinguishes between voyeur and lover. Here such banality is to be found in Rubens's compulsive painting of the fat softness of Hélène Fourment's flesh which continually breaks every ideal convention of form and (to him) continually offers the promise of her extraordinary particularity.

The nude in European oil painting is usually presented as an admirable expression of the European humanist spirit. This spirit was inseparable from individualism. And without the development of a highly conscious individualism the exceptions to the tradition (extremely personal images of the naked), would never have been painted. Yet the tradition contained a contradiction which it could not itself resolve. A few individual artists intuitively recognized this and resolved the contradiction in their own terms, but their solutions could never enter the tradition's *cultural* terms.

The contradiction can be stated simply. On the one hand the individualism of the artist, the thinker, the patron, the owner: on the other hand, the person who is the object of their activities – the woman – treated as a thing or an abstraction.

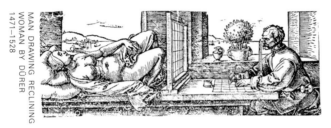

MAN DRAWING RECLINING WOMAN BY DÜRER 1471–1528

Dürer believed that the ideal nude ought to be constructed by taking the face of one body, the breasts of another, the legs of a third, the shoulders of a fourth, the hands of a fifth – and so on.

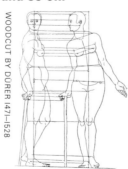

WOODCUT BY DÜRER 1471–1528

The result would glorify Man. But the exercise presumed a remarkable indifference to who any one person really was.

In the art-form of the European nude the painters and spectator-owners were usually men and the persons treated as objects, usually women. This unequal relationship is so deeply embedded in our culture that it still structures the consciousness of many women. They do to themselves what men do to them. They survey, like men, their own femininity.

In modern art the category of the nude has become less important. Artists themselves began to question it. In this, as in many other respects, Manet represented a turning point. If one compares his Olympia with Titian's original, one sees a woman, cast in the traditional role, beginning to question that role, somewhat defiantly.

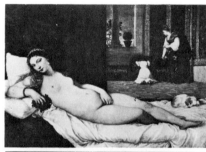

THE VENUS OF URBINO BY TITIAN C 1487–1576

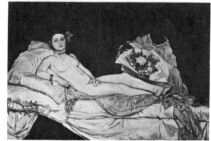

OLYMPIA BY MANET 1832–1883

The ideal was broken. But there was little to replace it except the 'realism' of the prostitute – who became the quintessential woman of early avant-garde twentieth-century painting. (Toulouse-Lautrec, Picasso, Rouault, German Expressionism, etc.) In academic painting the tradition continued.

Today the attitudes and values which informed that tradition are expressed through other more widely diffused media – advertising, journalism, television.

But the essential way of seeing women, the essential use to which their images are put, has not changed. Women are depicted in a quite different way from men — not because the feminine is different from the masculine — but because the 'ideal' spectator is always assumed to be male and the image of the woman is designed to flatter him. If you have any doubt that this is so, make the following experiment. Choose from this book an image of a traditional nude. Transform the woman into a man. Either in your mind's eye or by drawing on the reproduction. Then notice the violence which that transformation does. Not to the image, but to the assumptions of a likely viewer.

4

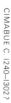

CIMABUE C. 1240—1302?

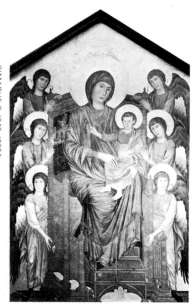

PIERO DELLA FRANCESCA 1410/20—1492

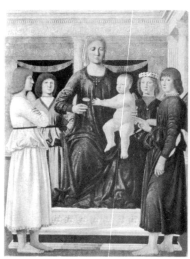

FRA FILIPPO LIPPI 1457/8—1504

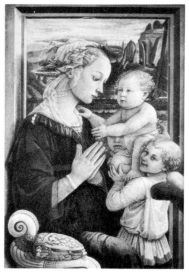

GERARD DAVID 1523

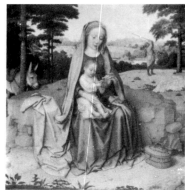

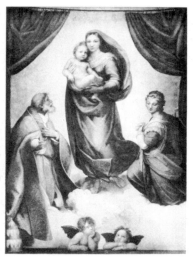

RAPHAEL 1483–1520

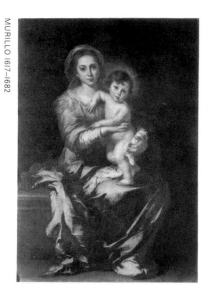

MURILLO 1617–1682

FORD MADOX BROWN 1821–1893

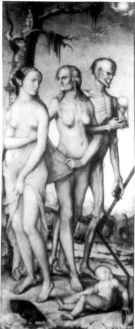

VENUS AND MARS 15TH CENTURY

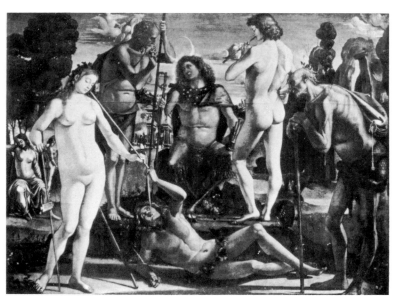

PAN 15TH CENTURY

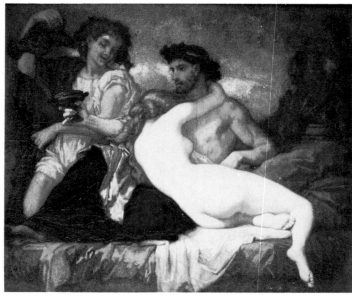

PAN AND SYRINX 18TH CENTURY

LOVE SEDUCING INNOCENCE, PLEASURE LEADING HER ON, REMORSE FOLLOWING 18TH CENTURY

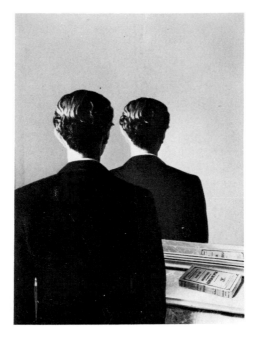

5

Oil paintings often depict things. Things which in reality are buyable. To have a thing painted and put on a canvas is not unlike buying it and putting it in your house. If you buy a painting you buy also the look of the thing it represents.

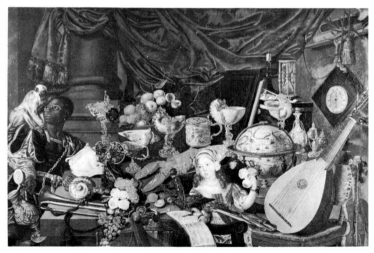

PASTON TREASURES AT OXNEAD HALL.
DUTCH SCHOOL. C. 1665

This analogy between *possessing* and the way of seeing which is incorporated in oil painting, is a factor usually ignored by art experts and historians. Significantly enough it is an anthropologist who has come closest to recognizing it.

Lévi-Strauss writes[*]:

It is this avid and ambitious desire to take possession of the object for the benefit of the owner or even of the spectator which seems to me to constitute one of the outstandingly original features of the art of Western civilization.

If this is true — though the historical span of Lévi-Strauss's generalization may be too large — the tendency reached its peak during the period of the traditional oil painting.

The term *oil painting* **refers to more than a technique. It defines an art form. The technique of mixing pigments with oil had existed since the ancient world. But the oil painting as an art form was not born until there was a need to develop and perfect this technique (which soon involved using canvas instead of wooden panels) in order to express a particular view of life for which the techniques of tempera or fresco were inadequate. When oil paint was first used — at the beginning of the fifteenth century in Northern Europe — for painting pictures of a new character, this character was somewhat inhibited by the survival of various medieval artistic conventions. The oil painting did not fully establish its own norms, its own way of seeing, until the sixteenth century.**

Nor can the end of the period of the oil painting be dated exactly. Oil paintings are still being painted today. Yet the basis of its traditional way of seeing was undermined by Impressionism and overthrown by Cubism. At about the same time the photograph took the place of the oil painting as the principal source of visual imagery. For these reasons the period of the traditional oil painting may be roughly set as between 1500 and 1900.

The tradition, however, still forms many of our cultural assumptions. It defines what we mean by pictorial likeness. Its norms still affect the way we see such subjects as landscape, women, food, dignitaries, mythology. It supplies us with our archetypes of 'artistic genius'. And the history of the tradition, as it is usually taught, teaches us that art prospers if enough individuals in society have a love of art.

What is a love of art?

* Conversations with Charles Charbonnier, Cape Editions

Let us consider a painting which belongs to the tradition whose subject is an art lover.

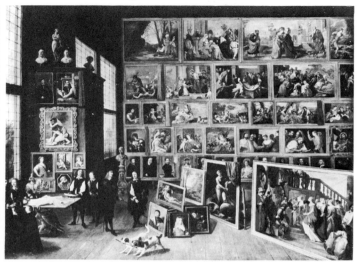

What does it show?
The sort of man in the seventeenth century for whom painters painted their paintings.

What are these paintings?
Before they are anything else, they are themselves objects which can be bought and owned. Unique objects. A patron cannot be surrounded by music or poems in the same way as he is surrounded by his pictures.

It is as though the collector lives in a house built of paintings. What is their advantage over walls of stone or wood?

They show him sights: sights of what he may possess.

Again, Lévi-Strauss comments on how a collection of paintings can confirm the pride and amour-propre of the collector.

For Renaissance artists, painting was perhaps an instrument of knowledge but it was also an instrument of possession, and we must not forget, when we are dealing with Renaissance painting, that it was only possible because of the immense fortunes which were being amassed in Florence and elsewhere, and that rich Italian merchants looked upon painters as agents, who allowed them to confirm their possession of all that was beautiful and desirable in the world. The pictures in a Florentine palace represented a kind of microcosm in which the proprietor, thanks to his artists, had recreated within easy reach and in as real a form as possible, all those features of the world to which he was attached.

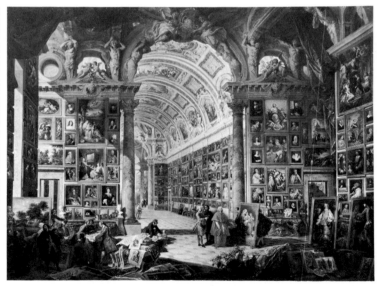

PICTURE GALLERY OF CARDINAL VALENTI GONZAGA BY PANINI 1692–1765/8

The art of any period tends to serve the ideological interests of the ruling class. If we were simply saying that European art between 1500 and 1900 served the interests of the successive ruling classes, all of whom depended in different ways on the new power of capital, we should not be saying anything very new. What is being

proposed is a little more precise; that a way of seeing the world, which was ultimately determined by new attitudes to property and exchange, found its visual expression in the oil painting, and could not have found it in any other visual art form.

Oil painting did to appearances what capital did to social relations. It reduced everything to the equality of objects. Everything became exchangeable because everything became a commodity. All reality was mechanically measured by its materiality. The soul, thanks to the Cartesian system, was saved in a category apart. A painting could speak to the soul — by way of what it referred to, but never by the way it envisaged. Oil painting conveyed a vision of total exteriority.

Pictures immediately spring to mind to contradict this assertion. Works by Rembrandt, El Greco, Giorgione, Vermeer, Turner, etc. Yet if one studies these works in relation to the tradition as a whole, one discovers that they were exceptions of a very special kind.

The tradition consisted of many hundreds of thousands of canvases and easel pictures distributed throughout Europe. A great number have not survived. Of those which have survived only a small fraction are seriously

treated today as works of fine art, and of this fraction another small fraction comprises the actual pictures repeatedly reproduced and presented as the work of 'the masters'.

Visitors to art museums are often overwhelmed by the number of works on display, and by what they take to be their own culpable inability to concentrate on more than a few of these works. In fact such a reaction is altogether reasonable. Art history has totally failed to come to terms with the problem of the relationship between the outstanding work and the average work of the European tradition. The notion of Genius is not in itself an adequate answer. Consequently the confusion remains on the walls of the galleries. Third-rate works surround an outstanding work without any recognition – let alone explanation – of what fundamentally differentiates them.

The art of any culture will show a wide differential of talent. But in no other culture is the difference between 'masterpiece' and average work so large as in the tradition of the oil painting. In this tradition the difference is not just a question of skill or imagination, but also of morale. The average work – and increasingly after the seventeenth century – was a work produced more or less cynically: that is to say the values it was nominally expressing were less meaningful to the painter than the finishing of the commission or the selling of his product. Hack work is not the result of either clumsiness or provincialism; it is the result of the market making more insistent demands than the art. The period of the oil painting corresponds with the rise of the open art market. And it is in this contradiction between art and market that the explanations must be sought for what amounts to the contrast, the antagonism existing between the exceptional work and the average.

Whilst acknowledging the existence of the exceptional works, to which we shall return later, let us first look broadly at the tradition.

What distinguishes oil painting from any other form of painting is its special ability to render the tangibility, the texture, the lustre, the solidity of what it depicts. It defines the real as that which you can put your hands on.

Although its painted images are two-dimensional, its potential of illusionism is far greater than that of sculpture, for it can suggest objects possessing colour, texture and temperature, filling a space and, by implication, filling the entire world.

Holbein's painting of The Ambassadors **(1533)** stands at the beginning of the tradition and, as often happens with a work at the opening of a new period, its character is undisguised. The way it is painted shows what it is about. How is it painted?

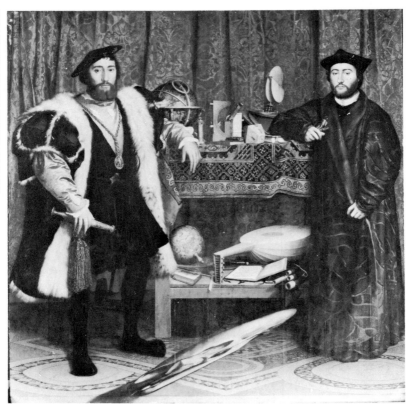

It is painted with great skill to create the illusion in the spectator that he is looking at real objects and materials. We pointed out in the first essay that the sense of touch was like a restricted, static sense of sight. Every square inch of the surface of this painting, whilst remaining purely visual, appeals to, importunes, the sense of touch. The eye moves from fur to silk to metal to wood to velvet to marble to paper to felt, and each time what the eye perceives is already translated, within the painting itself, into the language of tactile sensation. The two men have a certain presence and there are many objects which symbolize ideas, but it is the materials, the stuff, by which the men are surrounded and clothed which dominate the painting.

Except for the faces and hands, there is not a surface in this picture which does not make one aware of how it has been elaborately worked over – by weavers, embroiderers, carpet-makers, goldsmiths, leather workers, mosaic-makers, furriers, tailors, jewellers – and of how this working-over and the resulting richness of each surface has been finally worked-over and reproduced by Holbein the painter.

This emphasis and the skill that lay behind it was to remain a constant of the tradition of oil painting.

Works of art in earlier traditions celebrated wealth. But wealth was then a symbol of a fixed social or divine order. Oil painting celebrated a new kind of wealth – which was dynamic and which found its only sanction in the supreme buying power of money. Thus painting itself had to be able to demonstrate the desirability of what money could buy. And the visual desirability of what can be bought lies in its tangibility, in how it will reward the touch, the hand, of the owner.

In the foreground of Holbein's Ambassadors **there
is a mysterious, slanting, oval form. This represents a highly
distorted skull: a skull as it might be seen in a distorting
mirror. There are several theories about how it was painted
and why the ambassadors wanted it put there. But all agree
that it was a kind of memento mori: a play on the medieval idea
of using a skull as a continual reminder of the presence of
death. What is significant for our argument is that the skull is
painted in a (literally) quite different optic from everything
else in the picture. If the skull had been painted like the rest,
its metaphysical implication would have disappeared; it would
have become an object like everything else, a mere part of a
mere skeleton of a man who happened to be dead.**

**This was a problem which persisted throughout
the tradition. When metaphysical symbols are introduced (and
later there were painters who, for instance, introduced
realistic skulls as symbols of death), their symbolism is usually
made unconvincing or unnatural by the unequivocal, static
materialism of the painting-method.**

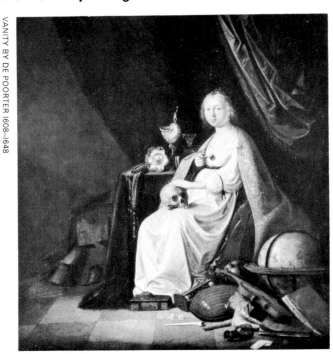

VANITY BY DE POORTER 1608–1648

91

It is the same contradiction which makes the average religious painting of the tradition appear hypocritical. The claim of the theme is made empty by the way the subject is painted. The paint cannot free itself of its original propensity to procure the tangible for the immediate pleasure of the owner. Here, for example, are three paintings of Mary Magdalene.

THE MAGDALEN READING STUDIO OF AMBROSIUS BENSON, ACTIVE 1519–1550

MARY MAGDALENE BY VAN DER WERFF 1659–1722

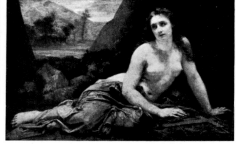

THE PENITENT MAGDALEN BY BAUDRY, SALON OF 1859

The point of her story is that she so loved Christ that she repented of her past and came to accept the mortality of flesh and the immortality of the soul. Yet the way the pictures are painted contradicts the essence of this story. It is as though the transformation of her life brought about by her repentance has not taken place. The method of painting is incapable of making the renunciation she is meant to have made. She is painted as being, before she is anything else, a takeable and desirable woman. She is still the compliant object of the painting-method's seduction.

It is interesting to note here the exceptional case of William Blake. As a draughtsman and engraver Blake learnt according to the rules of the tradition. But when he came to make paintings, he very seldom used oil paint and, although he still relied upon the traditional conventions of drawing, he did everything he could to make his figures lose substance, to become transparent and indeterminate one from the other, to defy gravity, to be present but intangible, to glow without a definable surface, not to be reducible to objects.

This wish of Blake's to transcend the 'substantiality' of oil paint derived from a deep insight into the meaning and limitations of the tradition.

Let us now return to the two ambassadors, to their presence as men. This will mean reading the painting differently: not at the level of what it shows within its frame, but at the level of what it refers to outside it.

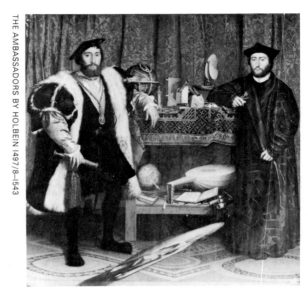

The two men are confident and formal; as between each other they are relaxed. But how do they look at the painter – or at us? There is in their gaze and their stance a curious lack of expectation of any recognition. It is as though in principle their worth cannot be recognized by others. They look as though they are looking at something of which they are not part. At something which surrounds them but from which they wish to exclude themselves. At the best it may be a crowd honouring them; at the worst, intruders.

What were the relations of such men with the rest of the world?

The painted objects on the shelves between them were intended to supply – to the few who could read the allusions – a certain amount of information about their position in the world. Four centuries later we can interpret this information according to our own perspective.

The scientific instruments on the top shelf were for navigation. This was the time when the ocean trade routes were being opened up for the slave trade and for the traffic which was to siphon the riches from other continents into Europe, and later supply the capital for the take-off of the Industrial Revolution.

In 1519 Magellan had set out, with the backing of Charles V, to sail round the world. He and an astronomer friend, with whom he had planned the voyage, arranged with the Spanish court that they personally were to keep twenty per cent of the profits made, and the right to run the government of any land they conquered.

The globe on the bottom shelf is a new one which charts this recent voyage of Magellan's. Holbein has added to the globe the name of the estate in France which belonged to the ambassador on the left. Beside the globe are a book of arithmetic, a hymn book and a lute. To colonize a land it was necessary to convert its people to Christianity and accounting, and thus to prove to them that European civilization was the most advanced in the world. Its art included.

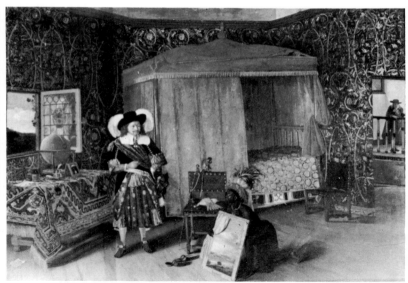

ADMIRAL DE RUYTER IN THE CASTLE OF ELMINA
BY DE WITTE 1617–1692

The African kneels to hold up an oil painting to his master. The painting depicts the castle above one of the principal centres of the West African slave trade.

How directly or not the two ambassadors were involved in the first colonizing ventures is not particularly important, for what we are concerned with here is a stance towards the world; and this was general to a whole class. The two ambassadors belonged to a class who were convinced that the world was there to furnish their residence in it. In its extreme form this conviction was confirmed by the relations being set up between colonial conqueror and the colonized.

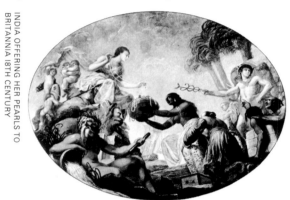

INDIA OFFERING HER PEARLS TO BRITANNIA 18TH CENTURY

These relations between conqueror and colonized tended to be self-perpetuating. The sight of the other confirmed each in his inhuman estimate of himself. The circularity of the relationship can be seen in the following diagram – as also the mutual solitude. The way in which each sees the other confirms his own view of himself.

The gaze of the ambassadors is both aloof and wary. They expect no reciprocity. They wish the image of their presence to impress others with their vigilance and their distance. The presence of kings and emperors had once impressed in a similar way, but their images had been comparatively impersonal. What is new and disconcerting here is the *individualized presence* which needs to suggest *distance*. Individualism finally posits equality. Yet equality must be made inconceivable.

The conflict again emerges in the painting-method. The surface verisimilitude of oil painting tends to make the viewer assume that he is close to – within touching distance of – any object in the foreground of the picture. If the object is a person such proximity implies a certain intimacy.

FERDINAND THE SECOND OF TUSCANY AND VITTORIA DELLA ROVERE BY SUTTERMANS 1597–1681

Yet the painted public portrait must insist upon a formal distance. It is this – and not technical inability on the part of the painter – which makes the average portrait of the tradition appear stiff and rigid. The artificiality is deep within its own terms of seeing, because the subject has to be seen simultaneously from close-to and from afar. The analogy is with specimens under a microscope.

They are there in all their particularity and we can study them, but it is impossible to imagine them considering us in a similar way.

MR AND MRS WILLIAM ATHERTON BY DEVIS 1711–1787

The formal portrait, as distinct from the self-portrait or the informal portrait of the painter's friend never resolved this problem. But as the tradition continued, the painting of the sitter's face became more and more generalized.

THE BEAUMONT FAMILY BY ROMNEY 1734–1802

His features became the mask which went with the costume. Today the final stage of this development can be seen in the puppet tv appearance of the average politician.

Let us now briefly look at some of the genres of oil painting — categories of painting which were part of its tradition but exist in no other.

Before the tradition of oil painting, medieval painters often used gold-leaf in their pictures. Later gold disappeared from paintings and was only used for their frames. Yet many oil paintings were themselves simple demonstrations of what gold or money could buy. Merchandise became the actual subject-matter of works of art.

STILL LIFE WITH A LOBSTER
BY DE HEEM 1606–1684

Here the edible is made visible. Such a painting is a demonstration of more than the virtuosity of the artist. It confirms the owner's wealth and habitual style of living.

Paintings of animals. Not animals in their natural condition, but livestock whose pedigree is emphasized as a proof of their value, and whose pedigree emphasizes the social status of their owners. (Animals painted like pieces of furniture with four legs.)

LINCOLNSHIRE OX
BY STUBBS 1724–1806

Paintings of objects. Objects which, significantly enough, became known as *objets d'art*.

Paintings of buildings – buildings not considered as ideal works of architecture, as in the work of some early Renaissance artists – but buildings as a feature of landed property.

The highest category in oil painting was the history or mythological picture. A painting of Greek or ancient figures was automatically more highly esteemed than a still-life, a portrait or a landscape. Except for certain exceptional works in which the painter's own personal lyricism was expressed, these mythological paintings strike us today as the most vacuous of all. They are like tired tableaux in wax that won't melt. Yet their prestige and their emptiness were directly connected.

Until very recently — and in certain milieux even today — a certain moral value was ascribed to the study of the classics. This was because the classic texts, whatever their intrinsic worth, supplied the higher strata of the ruling class with a system of references for the forms of their own idealized behaviour. As well as poetry, logic and philosophy, the classics offered a system of etiquette. They offered examples of how the heightened moments of life — to be found in heroic action, the dignified exercise of power, passion, courageous death, the noble pursuit of pleasure — should be lived, or, at least, should be seen to be lived.

Yet why are these pictures so vacuous and so perfunctory in their evocation of the scenes they are meant to recreate? They did not need to stimulate the imagination. If they had, they would have served their purpose less well. Their purpose was not to transport their spectator-owners into new experience, but to embellish such experience as they already possessed. Before these canvases the spectator-owner hoped to see the classic face of his own passion or grief or generosity. The idealized appearances he found in the painting were an aid, a support, to his own view of himself. In those appearances he found the guise of his own (or his wife's or his daughters') nobility.

Sometimes the borrowing of the classic guise was simple, as in Reynolds's painting of the daughters of the family dressed up as Graces decorating Hymen.

GRACES DECORATING HYMEN BY REYNOLDS 1723—1792

Sometimes the whole mythological scene functions like a garment held out for the spectator-owner to put his arms into and wear. The fact that the scene is substantial, and yet, behind its substantiality, empty, facilitates the 'wearing' of it.

OSSIAN RECEIVING NAPOLEON'S MARSHALLS IN VALHALLA BY GIRODET 1767/1824

The so-called 'genre' picture – the picture of 'low life' – was thought of as the opposite of the mythological picture. It was vulgar instead of noble. The purpose of the 'genre' picture was to prove – either positively or negatively – that virtue in this world was rewarded by social and financial success. Thus, those who could afford to buy these pictures – cheap as they were – had their own virtue confirmed. Such pictures were particularly popular with the newly arrived bourgeoisie who identified themselves not with the characters painted but with the moral which the scene illustrated. Again, the faculty of oil paint to create the illusion of substantiality lent plausibility to a sentimental lie: namely that it was the honest and hard-working who prospered, and that the good-for-nothings deservedly had nothing.

Adriaen Brouwer was the only exceptional 'genre' painter. His pictures of cheap taverns and those who ended up in them, are painted with a bitter and direct realism which precludes sentimental moralizing. As a result his pictures were never bought – except by a few other painters such as Rembrandt and Rubens.

The average 'genre' painting – even when painted by a 'master' like Hals – was very different.

LAUGHING FISHERBOY BY HALS 1580—1666

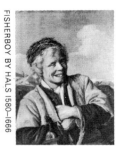

FISHERBOY BY HALS 1580—1666

These people belong to the poor. The poor can be seen in the street outside or in the countryside. Pictures of the poor inside the house, however, are reassuring. Here the painted poor smile as they offer what they have for sale. (They smile showing their teeth, which the rich in pictures never do.) They smile at the better-off — to ingratiate themselves, but also at the prospect of a sale or a job. Such pictures assert two things: that the poor are happy, and that the better-off are a source of hope for the world.

Landscape, of all the categories of oil painting, is the one to which our argument applies least.

AN EXTENSIVE LANDSCAPE WITH RUINS BY RUISDAEL 1628/9—1682

Prior to the recent interest in ecology, nature was not thought of as the object of the activities of capitalism; rather it was thought of as the arena in which capitalism and social life and each individual life had its being. Aspects of nature were objects of scientific study, but nature-as-a-whole defied possession.

RIVER SCENE WITH FISHERMEN LANDING A NET BY VAN GOYEN 1596–1656

One might put this even more simply. The sky has no surface and is intangible; the sky cannot be turned into a thing or given a quantity. And landscape painting begins with the problem of painting sky and distance.

The first pure landscapes – painted in Holland in the seventeenth century – answered no direct social need. (As a result Ruysdael starved and Hobbema had to give up.) Landscape painting was, from its inception, a relatively independent activity. Its painters naturally inherited and so, to a large extent, were forced to continue the methods and norms of the tradition. But each time the tradition of oil painting was significantly modified, the first initiative came from landscape painting. From the seventeenth century onwards the exceptional innovators in terms of vision and therefore technique were Ruysdael, Rembrandt (the use of light in his later work derived from his landscape studies), Constable (in his sketches), Turner and, at the end of the period, Monet and the Impressionists. Furthermore, their innovations led progressively away from the substantial and tangible towards the indeterminate and intangible.

Nevertheless the special relation between oil painting and property did play a certain role even in the development of landscape painting. Consider the well-known example of Gainsborough's Mr and Mrs Andrews.

MR AND MRS ANDREWS BY GAINSBOROUGH 1727–1788

· Kenneth Clark, *Landscape into Art* (John Murray, London)

Kenneth Clark* has written about Gainsborough and this canvas:

At the very beginning of his career his pleasure in what he saw inspired him to put into his pictures backgrounds as sensitively observed as the corn-field in which are seated Mr and Mrs Andrews. This enchanting work is painted with such love and mastery that we should have expected Gainsborough to go further in the same direction; but he gave up direct painting, and evolved the melodious style of picture-making by which he is best known. His recent biographers have thought that the business of portrait painting left him no time to make studies from nature, and they have quoted his famous letter about being 'sick of portraits and wishing to take his Viol de Gamba and walk off to some sweet village where he can paint landscips', to support the view that he would have been a naturalistic landscape painter if he had had the opportunity. But the Viol de Gamba letter is only part of Gainsborough's Rousseauism. His real opinions on the subject are contained in a letter to a patron who had been so

simple as to ask him for a painting of his park: 'Mr Gainsborough presents his humble respects to Lord Hardwicke, and shall always think it an honour to be employed in anything for His Lordship; but with regard to *real views* from Nature in this country, he has never seen any place that affords a subject equal to the poorest imitations of Gaspar or Claude.'

Why did Lord Hardwicke want a picture of his park? Why did Mr and Mrs Andrews commission a portrait of themselves with a recognizable landscape of their own land as background?

They are not a couple in Nature as Rousseau imagined nature. They are landowners and their proprietary attitude towards what surrounds them is visible in their stance and their expressions.

Professor Lawrence Gowing has protested indignantly against the implication that Mr and Mrs Andrews were interested in property:

Before John Berger manages to interpose himself again between us and the visible meaning of a good picture, may I point out that there is evidence to confirm that Gainsborough's Mr and Mrs Andrews were doing something more with their stretch of country than merely owning it. The explicit theme of a contemporary and precisely analogous design by Gainsborough's mentor Francis Hayman suggests that the people in such pictures were engaged in philosophic enjoyment of 'the great Principle ... the genuine Light of uncorrupted and unperverted *Nature*.'

The professor's argument is worth quoting because it is so striking an illustration of the disingenuousness that bedevils the subject of art history. Of course it is very possible that Mr and Mrs Andrews were engaged in the philosophic enjoyment of unperverted Nature. But this in no way precludes them from being at the same time proud landowners. In most cases the possession of private land was the precondition for such philosophic enjoyment — which was not uncommon among the landed gentry. Their enjoyment of 'uncorrupted and unperverted nature' did not, however, usually include the nature of other men. The sentence of poaching at that time was deportation. If a man stole a potato he risked a public whipping ordered by the magistrate who would be a landowner. There were very strict property limits to what was considered *natural*.

The point being made is that, among the pleasures their portrait gave to Mr and Mrs Andrews, was the pleasure of seeing themselves depicted as landowners and this pleasure was enhanced by the ability of oil paint to render their land in all its substantiality. And this is an observation which needs to be made, precisely because the cultural history we are normally taught pretends that it is an unworthy one.

Our survey of the European oil painting has been very brief and therefore very crude. It really amounts to no more than a project for study – to be undertaken perhaps by others. But the starting point of the project should be clear. The special qualities of oil painting lent themselves to a special system of conventions for representing the visible. The sum total of these conventions is the way of seeing invented by oil painting. It is usually said that the oil painting in its frame is like an imaginary window open on to the world. This is roughly the tradition's own image of itself – even allowing for all the stylistic changes (Mannerist, Baroque, Neo-Classic, Realist, etc.) which took place during four centuries. We are arguing that if one studies the culture of the European oil painting as a whole, and if one leaves aside its own claims for itself, its model is not so much a framed window open on to the world as a safe let into the wall, a safe in which the visible has been deposited.

We are accused of being obsessed by property. The truth is the other way round. It is the society and culture in question which is so obsessed. Yet to an obsessive his obsession always seems to be of the nature of things and so is not recognized for what it is. The relation between property and art in European culture appears natural to that culture, and consequently if somebody demonstrates the extent of the property interest in a given cultural field, it is said to be a demonstration of *his* obsession. And this allows the Cultural Establishment to project for a little longer its false rationalized image of itself.

The essential character of oil painting has been obscured by an almost universal misreading of the relationship between its 'tradition' and its 'masters'. Certain exceptional artists in exceptional circumstances broke free of the norms of the tradition and produced work that was diametrically opposed to its values; yet these artists are acclaimed as the tradition's supreme representatives: a claim which is made easier by the fact that after their death, the tradition closed around their work, incorporating minor technical innovations, and continuing as though nothing of principle had been disturbed. This is why Rembrandt or Vermeer or Poussin or Chardin or Goya or Turner had no followers but only superficial imitators.

From the tradition a kind of stereotype of 'the great artist' has emerged. This great artist is a man whose life-time is consumed by struggle: partly against material circumstances, partly against incomprehension, partly against himself. He is imagined as a kind of Jacob wrestling with an Angel. (The examples extend from Michelangelo to Van Gogh.) In no other culture has the artist been thought of in this way. Why then in this culture? We have already referred to the exigencies of the open art market. But the struggle was not only to live. Each time a painter realized that he was dissatisfied with the limited role of painting as a celebration of material property and of the status that accompanied it, he inevitably found himself struggling with the very language of his own art as understood by the tradition of his calling.

The two categories of exceptional works and average (typical) works are essential to our argument. But they cannot be applied mechanically as critical criteria. The critic must understand the terms of the antagonism. Every exceptional work was the result of a prolonged successful struggle. Innumerable works involved no struggle. There were also prolonged yet unsuccessful struggles.

To be an exception a painter whose vision had been formed by the tradition, and who had probably studied as an apprentice or student from the age of sixteen, needed to recognize his vision for what it was, and then to separate it from the usage for which it had been developed. Single-handed he had to contest the norms of the art that had formed him. He had to see himself as a painter in a way that denied the seeing of a painter. This meant that he saw himself doing something that nobody else could foresee. The degree of effort required is suggested in two self-portraits by Rembrandt.

The first was painted in 1634 when he was twenty-eight; the second thirty years later. But the difference between them amounts to something more than the fact that age has changed the painter's appearance and character.

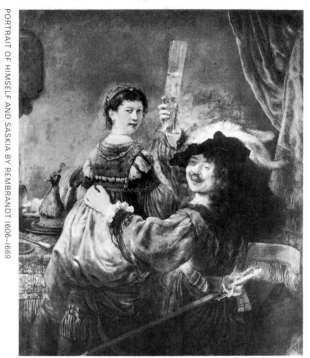

PORTRAIT OF HIMSELF AND SASKIA BY REMBRANDT 1606–1669

The first painting occupies a special place in, as it were, the film of Rembrandt's life. He painted it in the year of his first marriage. In it he is showing off Saskia his bride. Within six years she will be dead. The painting is cited to sum up the so-called happy period of the artist's life. Yet if one approaches it now without sentimentality, one sees that its happiness is both formal and unfelt. Rembrandt is here using the traditional methods for their traditional purposes. His individual style may be becoming recognizable. But it is no more than the style of a new performer playing a traditional role. The painting as a whole remains an advertisement for the sitter's good fortune, prestige and wealth. (In this case Rembrandt's own.) And like all such advertisements it is heartless.

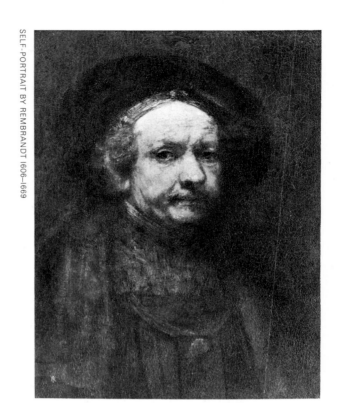

In the later painting he has turned the tradition against itself. He has wrested its language away from it. He is an old man. All has gone except a sense of the question of existence, of existence as a question. And the painter in him — who is both more and less than the old man — has found the means to express just that, using a medium which had been traditionally developed to exclude any such question.

6

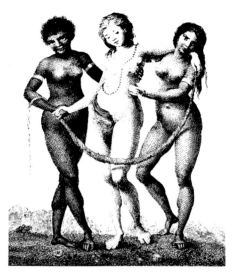

EUROPE SUPPORTED BY AFRICA AND AMERICA

PITY

MILDEW BLIGHTING EARS OF CORN

115

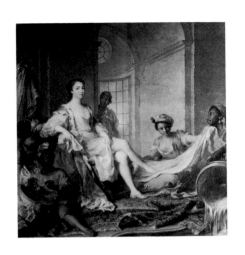

SALE OF PICTURES AND SLAVES IN THE ROTUNDA, NEW ORLEANS, 1842

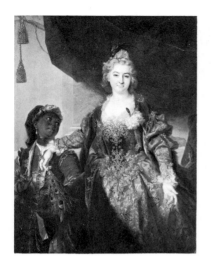

117

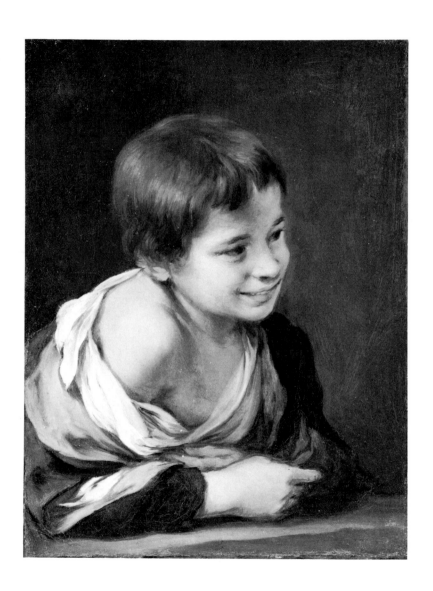

119

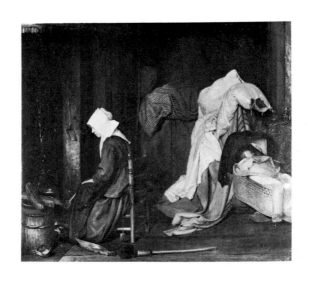

122

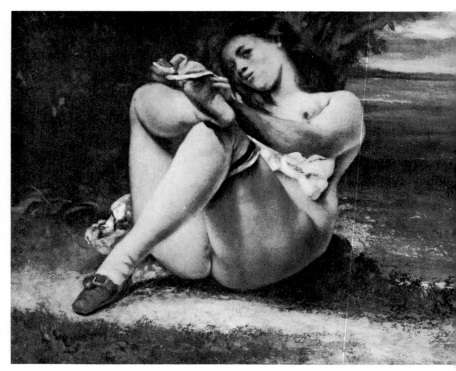

WOMAN WITH WHITE STOCKINGS

DEMOISELLES AU BORD DE LA SEINE

LES ROMAINES DE LA DECADENCE

LE SALON

THE ONDINE OF NIDDEN

MADAME CAHEN D'ANVERS

126

WITCHES SABBATH

THE TEMPTATION OF ST ANTHONY

PSYCHE'S BATH

LA FORTUNE

7

In the cities in which we live, all of us see hundreds of publicity images every day of our lives. No other kind of image confronts us so frequently.

In no other form of society in history has there been such a concentration of images, such a density of visual messages.

One may remember or forget these messages but briefly one takes them in, and for a moment they stimulate the imagination by way of either memory or expectation. The publicity image belongs to the moment. We see it as we turn

a page, as we turn a corner, as a vehicle passes us. Or we see it on a television screen whilst waiting for the commercial break to end. Publicity images also belong to the moment in the sense that they must be continually renewed and made up-to-date. Yet they never speak of the present. Often they refer to the past and always they speak of the future.

Morny Soap is a pure, fragrant dream.

MORNY SOAP 19p and 26p

ANGELO LITRICO

MAN AT C&A

We are now so accustomed to being addressed by these images that we scarcely notice their total impact. A person may notice a particular image or piece of information because it corresponds to some particular interest he has. But we accept the total system of publicity images as we accept an element of climate. For example, the fact that these images belong to the moment but speak of the future produces a strange effect which has become so familiar that we scarcely notice it. Usually it is *we* who pass the image – walking, travelling, turning a page; on the tv screen it is somewhat different but even then we are theoretically the active agent – we can look away, turn down the sound, make some coffee. Yet despite this, one has the impression that publicity images are continually passing us, like express trains on their way to some distant terminus. We are static; they are dynamic – until the newspaper is thrown away, the television programme continues or the poster is posted over.

Publicity is usually explained and justified as a competitive medium which ultimately benefits the public (the

consumer) and the most efficient manufacturers — and thus the national economy. It is closely related to certain ideas about freedom: freedom of choice for the purchaser: freedom of enterprise for the manufacturer. The great hoardings and the publicity neons of the cities of capitalism are the immediate visible sign of 'The Free World'.

For many in Eastern Europe such images in the West sum up what they in the East lack. Publicity, it is thought, offers a free choice.

It is true that in publicity one brand of manufacture, one firm, competes with another; but it is also true that every publicity image confirms and enhances every other. Publicity is not merely an assembly of competing messages: it is a language in itself which is always being used to make the same general proposal. Within publicity, choices are offered between this cream and that cream, that car and this car, but publicity as a system only makes a single proposal.

It proposes to each of us that we transform ourselves, or our lives, by buying something more.

This more, it proposes, will make us in some way richer — even though we will be poorer by having spent our money.

Publicity persuades us of such a transformation by showing us people who have apparently been transformed and are, as a result, enviable. The state of being envied is what constitutes glamour. And publicity is the process of manufacturing glamour.

It is important here not to confuse publicity
with the pleasure or benefits to be enjoyed from the things it
advertises. Publicity is effective precisely because it feeds
upon the real. Clothes, food, cars, cosmetics, baths, sunshine
are real things to be enjoyed in themselves. Publicity begins by
working on a natural appetite for pleasure. But it cannot offer
the real object of pleasure and there is no convincing
substitute for a pleasure in that pleasure's own terms. The
more convincingly publicity conveys the pleasure of bathing
in a warm, distant sea, the more the spectator-buyer will
become aware that he is hundreds of miles away from that
sea and the more remote the chance of bathing in it will seem
to him. This is why publicity can never really afford to be about
the product or opportunity it is proposing to the buyer who is
not yet enjoying it. Publicity is never a celebration of a
pleasure-in-itself. Publicity is always about the future buyer.
It offers him an image of himself made glamorous by the
product or opportunity it is trying to sell. The image then
makes him envious of himself as he might be. Yet what makes
this self-which-he-might-be enviable? The envy of others.
Publicity is about social relations, not objects. Its promise is
not of pleasure, but of happiness: happiness as judged from the
outside by others. The happiness of being envied is glamour.

132

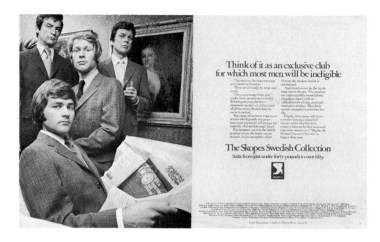

Being envied is a solitary form of reassurance. It depends precisely upon not sharing your experience with those who envy you. You are observed with interest but you do not observe with interest – if you do, you will become less enviable. In this respect the envied are like bureaucrats; the more impersonal they are, the greater the illusion (for themselves and for others) of their power. The power of the glamorous resides in their supposed happiness: the power of the bureaucrat in his supposed authority. It is this which explains the absent, unfocused look of so many glamour images. They look out *over* the looks of envy which sustain them.

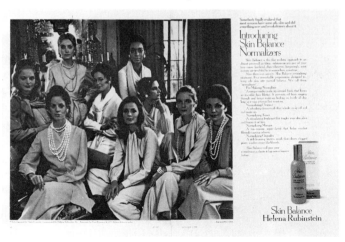

The spectator-buyer is meant to envy herself as she will become if she buys the product. She is meant to imagine herself transformed by the product into an object of envy for others, an envy which will then justify her loving herself. One could put this another way: the publicity image steals her love of herself as she is, and offers it back to her for the price of the product.

Does the language of publicity have anything in common with that of oil painting which, until the invention of the camera, dominated the European way of seeing during four centuries?

It is one of those questions which simply needs to be asked for the answer to become clear. There is a direct continuity. Only interests of cultural prestige have obscured it. At the same time, despite the continuity, there is a profound difference which it is no less important to examine.

There are many direct references in publicity to works of art from the past. Sometimes a whole image is a frank pastiche of a well-known painting.

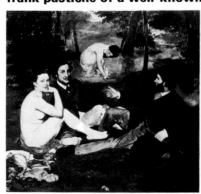

We could all use a little romance

Publicity images often use sculptures or paintings to lend allure or authority to their own message. Framed oil paintings often hang in shop windows as part of their display.

Any work of art 'quoted' by publicity serves two purposes. Art is a sign of affluence; it belongs to the good life; it is part of the furnishing which the world gives to the rich and the beautiful.

But a work of art also suggests a cultural authority, a form of dignity, even of wisdom, which is superior to any vulgar material interest; an oil painting belongs to the cultural heritage; it is a reminder of what it means to be a cultivated European. And so the quoted work of art (and this is why it is so useful to publicity) says two almost contradictory things at the same time: it denotes wealth and spirituality: it implies that the purchase being proposed is both a luxury and a cultural value. Publicity has in fact understood the tradition of the oil painting more thoroughly than most art historians. It has grasped the implications of the relationship between the work of art and its spectator-owner and with these it tries to persuade and flatter the spectator-buyer.

The continuity, however, between oil painting and publicity goes far deeper than the 'quoting' of specific paintings. Publicity relies to a very large extent on the language of oil painting. It speaks in the same voice about the same things. Sometimes the visual correspondences are so close that it is possible to play a game of 'Snap!' – putting almost identical images or details of images side by side.

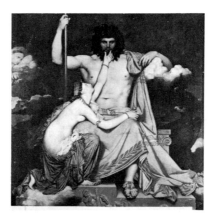

IS IT FUR REAL?

136

You can take a White Horse anywhere

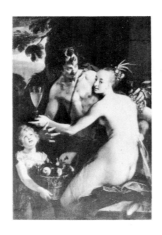

It is not, however, just at the level of exact pictorial correspondence that the continuity is important: it is at the level of the sets of signs used.

Compare the images of publicity and paintings in this book, or take a picture magazine, or walk down a smart shopping street looking at the window displays, and then turn over the pages of an illustrated museum catalogue, and notice how similarly messages are conveyed by the two media. A systematic study needs to be made of this. Here we can do no more than indicate a few areas where the similarity of the devices and aims is particularly striking.

The gestures of models (mannequins) and mythological figures.
The romantic use of nature (leaves, trees, water) to create a place where innocence can be refound.
The exotic and nostalgic attraction of the Mediterranean.
The poses taken up to denote stereotypes of women: serene mother (madonna),
free-wheeling secretary (actress, king's mistress),
perfect hostess (spectator-owner's wife),
sex-object (Venus, nymph surprised), etc.
The special sexual emphasis given to women's legs.
The materials particularly used to indicate luxury: engraved metal, furs, polished leather, etc.
The gestures and embraces of lovers, arranged frontally for the benefit of the spectator.
The sea, offering a new life.
The physical stance of men conveying wealth and virility.
The treatment of distance by perspective – offering mystery.
The equation of drinking and success.
The man as knight (horseman) become motorist.

Why does publicity depend so heavily upon the visual language of oil painting?

Publicity is the culture of the consumer society. It propagates through images that society's belief in itself. There are several reasons why these images use the language of oil painting.

Oil painting, before it was anything else, was a celebration of private property. As an art-form it derived from the principle that *you are what you have.*

It is a mistake to think of publicity supplanting the visual art of post-Renaissance Europe; it is the last moribund form of that art.

Is it Italian tile? Or a real Armstrong floor?

Come and play footsy with Armstrong

Publicity is, in essence, nostalgic. It has to sell the past to the future. It cannot itself supply the standards of its own claims. And so all its references to quality are bound to be retrospective and traditional. It would lack both confidence and credibility if it used a strictly contemporary language.

Publicity needs to turn to its own advantage the traditional education of the average spectator-buyer. What he has learnt at school of history, mythology, poetry can be used in the manufacturing of glamour. Cigars can be sold in the name of a King, underwear in connection with the Sphinx, a new car by reference to the status of a country house.

In the language of oil painting these vague historical or poetic or moral references are always present. The fact that they are imprecise and ultimately meaningless is an advantage: they should not be understandable, they should merely be reminiscent of cultural lessons half-learnt. Publicity makes all history mythical, but to do so effectively it needs a visual language with historical dimensions.

Lastly, a technical development made it easy to translate the language of oil painting into publicity clichés. This was the invention, about fifteen years ago, of cheap colour photography. Such photography can reproduce the colour and texture and tangibility of objects as only oil paint had been able to do before. Colour photography is to the spectator-buyer what oil paint was to the spectator-owner.

140

Both media use similar, highly tactile means to play upon the spectator's sense of acquiring the *real* thing which the image shows. In both cases his feeling that he can almost touch what is in the image reminds him how he might or does possess the real thing.

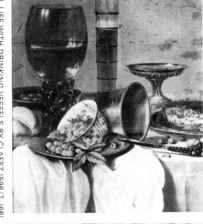
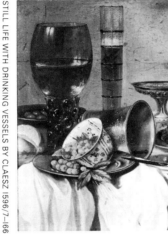

Sierra . Le soleil de midi .

arcoroc

Yet, despite this continuity of language, the function of publicity is very different from that of the oil painting. The spectator-buyer stands in a very different relation to the world from the spectator-owner.

The oil painting showed what its owner was already enjoying among his possessions and his way of life. It consolidated his own sense of his own value. It enhanced his view of himself as he already was. It began with facts, the facts of his life. The paintings embellished the interior in which he actually lived.

The purpose of publicity is to make the spectator marginally dissatisfied with his present way of life. Not with the way of life of society, but with his own within it. It suggests that if he buys what it is offering, his life will become better. It offers him an improved alternative to what he is.

The oil painting was addressed to those who made money out of the market. Publicity is addressed to those who constitute the market, to the spectator-buyer who is also the consumer-producer from whom profits are made twice over – as worker and then as buyer. The only places relatively free of publicity are the quarters of the very rich; their money is theirs to keep.

All publicity works upon anxiety. The sum of everything is money, to get money is to overcome anxiety.

Alternatively the anxiety on which publicity plays is the fear that having nothing you will be nothing.

Money is life. Not in the sense that without money you starve. Not in the sense that capital gives one class power over the entire lives of another class. But in the sense that money is the token of, and the key to, every human capacity. The power to spend money is the power to live. According to the legends of publicity, those who lack the power to spend money become literally faceless. Those who have the power become lovable.

Already one man in 21 has a different kind of spending power.

You can have it too, if you have a Barclaycard. It's the power to buy what you can actually afford, without using cash or cheque—at home and abroad. In Britain alone, 43,000 places take Barclaycard—shops, garages, restaurants, hotels, airlines. And you can obtain £25 in cash at any branch of Barclays.

Why not apply for a Barclaycard? It doesn't matter which bank you use, and it's issued free. (The retailer pays a small service charge on each purchase.) You just show your Barclaycard, sign the bill, and get a copy of it. That way you keep a straightforward record so you know exactly where you stand.

Later, we send you one statement for the whole month's Barclaycard purchases. If you pay that in full within 25 days of its date, you incur no extra charges for your purchases. You can, if you like, pay 10%

(minimum £2) each month of the amount outstanding and owe us the rest at a monthly interest of 1½%.

If you'd like to know more, collect a leaflet at any branch of Barclays, or fill in the coupon right now.

Please tell me everything about Barclaycard.
I am over 18.

Name

Address

Post to: Barclaycard, Juxon House,
94 St. Paul's Churchyard, London EC4

Publicity increasingly uses sexuality to sell any product or service. But this sexuality is never free in itself; it is a symbol for something presumed to be larger than it: the good life in which you can buy whatever you want. To be able to buy is the same thing as being sexually desirable; occasionally this is the explicit message of publicity as in the Barclaycard advertisement above. Usually it is the implicit message, i.e. If you are able to buy this product you will be lovable. If you cannot buy it, you will be less lovable.

For publicity the present is by definition insufficient. The oil painting was thought of as a permanent record. One of the pleasures a painting gave to its owner was the thought that it would convey the image of his present to the future of his descendants. Thus the oil painting was naturally painted in the present tense. The painter painted what was before him, either in reality or in imagination. The publicity image which is ephemeral uses only the future tense. With this you *will* become desirable. In these surroundings all your relationships *will* become happy and radiant.

144

Things happen after a badedas bath
(they say it's got something to do with the horse chestnuts)

badedas: Just a capful in your bath. Fantastic. Green waters which bubble like vintage champagne. Forget about soap. Just lie there, be cleansed more kindly, more gently than you'd believe possible. Enjoy the mysterious action of a special extract of horse chestnuts.

The fresh smell of deep green continental forests. And what happens afterwards? To the new, invigorated, re-born you? Quite simply, Lebensfreude. Which the British, masters of understatement, call joie de vivre.

badedas
the most stimulating thing since feeling daft with extract of horse chestnuts

Publicity principally addressed to the working class tends to promise a personal transformation through the function of the particular product it is selling (Cinderella); middle-class publicity promises a transformation of relationships through a general atmosphere created by an ensemble of products (The Enchanted Palace).

G-Plan a whole new way of life.

One of the beautiful advantages of investing in G-Plan's new Disc range is that you can start as you mean to go on.

For the first time you see spend the problem of deciding how many armchairs you want, or how long your new sofa should be.

With Disc a single supremely comfortable seating unit for your

bedroom can be transformed into an elegant armchair for wine study, or linked up to make a magnificent two-, three-, and even six-seater sofa for good living more. Each Disc unit is upholstered in three-inch layer of softest foam, easily balanced for maximum comfort in a choice of vital heathwood. And there's a choice of over 60 washproom

covers, too. This is whole brave furniture have a whole new way of life. Illustrated, just-on-sale units from £45. Send & price lists like. View G-Plan at leading furniture stores and ask for the catalogue of the whole range of G-Plan furniture.

E. Gomme Limited, High Wycombe, Buckinghamshire.

G-PLAN

145

Publicity speaks in the future tense and yet the achievement of this future is endlessly deferred. How then does publicity remain credible — or credible enough to exert the influence it does? It remains credible because the truthfulness of publicity is judged, not by the real fulfilment of its promises, but by the relevance of its fantasies to those of the spectator-buyer. Its essential application is not to reality but to day-dreams.

To understand this better we must go back to the notion of *glamour*.

Glamour is a modern invention. In the heyday of the oil painting it did not exist. Ideas of grace, elegance, authority amounted to something apparently similar but fundamentally different.

Mrs Siddons as seen by Gainsborough is not glamorous, because she is not presented as enviable and therefore happy. She may be seen as wealthy, beautiful, talented, lucky. But her qualities are her own and have been recognized as such. What she is does not entirely depend upon others wanting to be like her. She is not purely the creature of others' envy – which is how, for example, Andy Warhol presents Marilyn Monroe.

Glamour cannot exist without personal social envy being a common and widespread emotion. The industrial society which has moved towards democracy and then stopped half way is the ideal society for generating such an emotion. The pursuit of individual happiness has been acknowledged as a universal right. Yet the existing social conditions make the individual feel powerless. He lives in the contradiction between what he is and what he would like to be. Either he then becomes fully conscious of the contradiction and its causes, and so joins the political struggle for a full democracy which entails, amongst other things, the overthrow of capitalism; or else he lives, continually subject to an envy which, compounded with his sense of powerlessness, dissolves into recurrent day-dreams.

It is this which makes it possible to understand why publicity remains credible. The gap between what publicity actually offers and the future it promises, corresponds with the gap between what the spectator-buyer feels himself to be and what he would like to be. The two gaps become one; and instead of the single gap being bridged by action or lived experience, it is filled with glamorous day-dreams.

The process is often reinforced by working conditions.

The interminable present of meaningless working hours is 'balanced' by a dreamt future in which imaginary activity replaces the passivity of the moment. In his or her day-dreams the passive worker becomes the active consumer. The working self envies the consuming self.

No two dreams are the same. Some are instantaneous, others prolonged. The dream is always personal to the dreamer. Publicity does not manufacture the dream. All that it does is to propose to each one of us that we are not yet enviable – yet could be.

Publicity has another important social function. The fact that this function has not been planned as a purpose by those who make and use publicity in no way lessens its significance. Publicity turns consumption into a substitute for democracy. The choice of what one eats (or wears or drives) takes the place of significant political choice. Publicity helps to mask and compensate for all that is undemocratic within society. And it also masks what is happening in the rest of the world.

Publicity adds up to a kind of philosophical system. It explains everything in its own terms. It interprets the world.

The entire world becomes a setting for the fulfilment of publicity's promise of the good life. The world smiles at us. It offers itself to us. And because *everywhere* is imagined as offering itself to us, *everywhere* is more or less the same.

ALITALIA'S TWO FOR THE PRICE OF ONE HOLIDAYS

According to publicity, to be sophisticated is to live beyond conflict.

P.I.A. has the best places: LONDON · FRANKFURT · PARIS · GENEVA · ISTANBUL
BEIRUT · BAGHDAD · KUWAIT · DHAHRAN · TEHRAN · KARACHI · DACCA · KATHMANDU
CANTON · SHANGHAI · BAHRAIN · DOHA · DUBAI · JEDDAH · NAIROBI

PIA · PAKISTAN INTERNATIONAL AIRLINES

THE NEW PLACE

Publicity can translate even revolution into its own terms.

The contrast between publicity's interpretation of the world and the world's actual condition is a very stark one, and this sometimes becomes evident in the colour magazines which deal with news stories. Overleaf is the contents page of such a magazine.

THE SUNDAY TIMES *magazine*

Contents, June 6, 1971

The shock of such contrasts is considerable: not only because of the coexistence of the two worlds shown, but also because of the cynicism of the culture which shows them one above the other. It can be argued that the juxtaposition of images was not planned. Nevertheless the text, the photographs taken in Pakistan, the photographs taken for the advertisements, the editing of the magazine, the layout of the publicity, the printing of both, the fact that advertiser's pages and news pages cannot be co-ordinated – all these are produced by the same culture.

It is not, however, the moral shock of the contrast which needs emphasizing. Advertisers themselves can take account of the shock. The Advertisers Weekly (3 March 1972) reports that some publicity firms, now aware of the commercial danger of such unfortunate juxtapositions in news magazines, are deciding to use less brash, more sombre images, often in black and white rather than colour. What we need to realize is what such contrasts reveal about the nature of publicity.

Publicity is essentially *eventless*. It extends just as far as nothing else is happening. For publicity all real events are exceptional and happen only to strangers. In the Bangla Desh photographs, the events were tragic and distant. But the contrast would have been no less stark if they had been events near at hand in Derry or Birmingham. Nor is the contrast necessarily dependent upon the events being tragic. If they are tragic, their tragedy alerts our moral sense to the contrast. Yet if the events were joyous and if they were photographed in a direct and unstereotyped way the contrast would be just as great.

Publicity, situated in a future continually deferred, excludes the present and so eliminates all becoming, all development. Experience is impossible within it. All that happens, happens outside it.

The fact that publicity is eventless would be immediately obvious if it did not use a language which makes of tangibility an event in itself. Everything publicity shows is there awaiting acquisition. The act of acquiring has taken the place of all other actions, the sense of having has obliterated all other senses.

Publicity exerts an enormous influence and is a political phenomenon of great importance. But its offer is as narrow as its references are wide. It recognizes nothing except the power to acquire. All other human faculties or needs are made subsidiary to this power. All hopes are gathered together, made homogeneous, simplified, so that they become the intense yet vague, magical yet repeatable promise offered in every purchase. No other kind of hope or satisfaction or pleasure can any longer be envisaged within the culture of capitalism.

Publicity is the life of this culture – in so far as without publicity capitalism could not survive – and at the same time publicity is its dream.

Capitalism survives by forcing the majority, whom it exploits, to define their own interests as narrowly as possible. This was once achieved by extensive deprivation. Today in the developed countries it is being achieved by imposing a false standard of what is and what is not desirable.

List of Works Reproduced

original now destroyed, formerly Kaiser Friedrich Museum, Berlin

Acknowledgement is due to the following for permission to reproduce pictures in this book:

Sven Blomberg, 129, 134; City of Birmingham, 67 (bottom); City of Norwich Museums, 83; Chiddingstone Castle, 52; Euan Duff, 142 (bottom), 148; Evening Standard, 36 (bottom); Frans Hals Museum, 12; Giraudon, 50, 57, 66 (top left), 68 (bottom), 70 (bottom); Kunsthistorisches Museum, 27, 85; Mansell, 39, 60, 111, 112; Jean Mohr, 36 (top), 43 (bottom); National Film Archive, 17; National Gallery, 20, 23, 25 (bottom), 43 (top), 54, 70 (top), 74 (top), 75 (top), 87, 89, 92 (top left), 97, 100 (top), 103, 104, 105, 106, 117 (top left), 119, 120 (top left and bottom left), 120–1 (top and bottom), 141, 147; National Trust (Country Life), 76; Rijksmuseum, Amsterdam, 31; Tate Gallery, 98 (bottom), 102 (top), 122 (top right and bottom), 123 (middle right and top); Wadsworth Atheneum, Hartford, 86; Wallace Collection, 71 (top and bottom), 72, 75, 99, 116 (top), 121 (top and bottom); Walker Art Gallery, 99 (bottom).

To be continued by the reader . . .

PENGUIN ONLINE

READ MORE IN PENGUIN

In every corner of the world, on every subject under the sun, Penguin represents quality and variety – the very best in publishing today.

For complete information about books available from Penguin – including Puffins, Penguin Classics and Arkana – and how to order them, write to us at the appropriate address below. Please note that for copyright reasons the selection of books varies from country to country.

In the United Kingdom: Please write to *Dept. EP, Penguin Books Ltd, Bath Road, Harmondsworth, West Drayton, Middlesex UB7 0DA*

In the United States: Please write to *Consumer Services, Penguin Putnam Inc., 405 Murray Hill Parkway, East Rutherford, New Jersey 07073-2136.* VISA and MasterCard holders call 1-800-631-8571 to order Penguin titles

In Canada: Please write to *Penguin Books Canada Ltd, 10 Alcorn Avenue, Suite 300, Toronto, Ontario M4V 3B2*

In Australia: Please write to *Penguin Books Australia Ltd, 487 Maroondah Highway, Ringwood, Victoria 3134*

In New Zealand: Please write to *Penguin Books (NZ) Ltd, Private Bag 102902, North Shore Mail Centre, Auckland 10*

In India: Please write to *Penguin Books India Pvt Ltd, 11 Community Centre, Panchsheel Park, New Delhi 110017*

In the Netherlands: Please write to *Penguin Books Netherlands bv, Postbus 3507, NL-1001 AH Amsterdam*

In Germany: Please write to *Penguin Books Deutschland GmbH, Metzlerstrasse 26, 60594 Frankfurt am Main*

In Spain: Please write to *Penguin Books S. A., Bravo Murillo 19, 1°B, 28015 Madrid*

In Italy: Please write to *Penguin Italia s.r.l., Via Vittorio Emanuele 45/a, 20094 Corsico, Milano*

In France: Please write to *Penguin France, 12, Rue Prosper Ferradou, 31700 Blagnac*

In Japan: Please write to *Penguin Books Japan Ltd, Iidabashi KM-Bldg, 2-23-9 Koraku, Bunkyo-Ku, Tokyo 112-0004*

In South Africa: Please write to *Penguin Books South Africa (Pty) Ltd, P.O. Box 751093, Gardenview, 2047 Johannesburg*

READ MORE IN PENGUIN

LITERARY CRITICISM

The Practice of Writing David Lodge

This lively collection examines the work of authors ranging from the two Amises to Nabokov and Pinter; the links between private lives and published works; and the different techniques required in novels, stage plays and screenplays. 'These essays, so easy in manner, so well-built and informative, offer a fine blend of creative writing and criticism' *Sunday Times*

A Lover's Discourse Roland Barthes

'May be the most detailed, painstaking anatomy of desire we are ever likely to see or need again ... The book is an ecstatic celebration of love and language ... readers interested in either or both ... will enjoy savouring its rich and dark delights' *Washington Post*

The New Pelican Guide to English Literature Edited by Boris Ford

The indispensable critical guide to English and American literature in nine volumes, erudite yet accessible. From the ages of Chaucer and Shakespeare, via Georgian satirists and Victorian social critics, to the leading writers of the twentieth century, all literary life is here.

The Structure of Complex Words William Empson

'Twentieth-century England's greatest critic after T. S. Eliot, but whereas Eliot was the high priest, Empson was the *enfant terrible* ... *The Structure of Complex Words* is one of the linguistic masterpieces of the epoch, finding in the feel and tone of our speech whole sedimented social histories' *Guardian*

Vamps and Tramps Camille Paglia

'Paglia is a genuinely unconventional thinker ... Taken as a whole, the book gives an exceptionally interesting perspective on the last thirty years of intellectual life in America, and is, in its wacky way, a celebration of passion and the pursuit of truth' *Sunday Telegraph*

READ MORE IN PENGUIN

HISTORY

A History of Twentieth-Century Russia Robert Service

'A remarkable work of scholarship and synthesis . . . [it] demands to be read' *Spectator.* 'A fine book . . . It is a dizzying tale and Service tells it well; he has none of the ideological baggage that has so often bedevilled Western histories of Russia . . . A balanced, dispassionate and painstaking account' *Sunday Times*

A Monarchy Transformed: Britain 1603–1714 Mark Kishlansky

'Kishlansky's century saw one king executed, another exiled, the House of Lords abolished, and the Church of England reconstructed along Presbyterian lines . . . A masterly narrative, shot through with the shrewdness that comes from profound scholarship' *Spectator*

American Frontiers Gregory H. Nobles

'At last someone has written a narrative of America's frontier experience with sensitivity and insight. This is a book which will appeal to both the specialist and the novice' James M. McPherson, Princeton University

The Pleasures of the Past David Cannadine

'This is almost everything you ever wanted to know about the past but were too scared to ask . . . A fascinating book and one to strike up arguments in the pub' *Daily Mail.* 'He is erudite and rigorous, yet always fun. I can imagine no better introduction to historical study than this collection' *Observer*

Prague in Black and Gold Peter Demetz

'A dramatic and compelling history of a city Demetz admits to loving and hating . . . He embraces myth, economics, sociology, linguistics and cultural history . . . His reflections on visiting Prague after almost a half-century are a moving elegy on a world lost through revolutions, velvet or otherwise' *Literary Review*

READ MORE IN PENGUIN

ARCHAEOLOGY

The Penguin Dictionary of Archaeology
Warwick Bray and David Trump

The range of this dictionary is from the earliest prehistory to the civilizations before the rise of classical Greece and Rome. From the Abbevillian handaxe and the god Baal of the Canaanites to the Wisconsin and Würm glaciations of America and Europe, this dictionary concisely describes, in more than 1,600 entries, the sites, cultures, periods, techniques and terms of archaeology.

The Complete Dead Sea Scrolls in English Geza Vermes

The discovery of the Dead Sea Scrolls in the Judaean desert between 1947 and 1956 transformed our understanding of the Hebrew Bible, early Judaism and the origins of Christianity. 'No translation of the Scrolls is either more readable or more authoritative than that of Vermes' *The Times Higher Education Supplement*

Ancient Iraq Georges Roux

Newly revised and now in its third edition, *Ancient Iraq* covers the political, cultural and socio-economic history of Mesopotamia from the days of prehistory to the Christian era and somewhat beyond.

Breaking the Maya Code Michael D. Coe

Over twenty years ago, no one could read the hieroglyphic texts carved on the magnificent Maya temples and palaces; today we can understand almost all of them. The inscriptions reveal a culture obsessed with warfare, dynastic rivalries and ritual blood-letting. 'An entertaining, enlightening and even humorous history of the great searchers after the meaning that lies in the Maya inscriptions' *Observer*

READ MORE IN PENGUIN

ART AND ARCHITECTURE

An Outline of European Architecture Nikolaus Pevsner

Unique, authoritative, and encyclopedic in knowledge, this study of the history of European architecture has become established as a classic. Concentrating on outstanding and typical buildings, it traces the story of western architecture from the basilicas of Rome to the skyscrapers of the twentieth century.

Fully illustrated with nearly 300 photographs, drawings and plans, *An Outline of European Architecture* has been explanded in edition after edition, and has sold over half a million copies since it was first published.

Pioneers of Modern Design Nikolaus Pevsner

In this path-breaking, learned and yet immensely readable account, Pevsner considers the essential background to the pioneers' rejection of ornament, use of new materials and commitment to 'utility' and the machine age. Among the early masters of the Modern Movement were Voysey and Mackintosh in Britain, and Sullivan and Lloyd Wright in America. Finally, Gropius and his Bauhaus colleagues perfected the style. Their relationships, achievements and influence are described and celebrated in this classic survey.

The Penguin Dictionary of Art and Artists Peter and Linda Murray

'A vast amount of information intelligently presented, carefully detailed, abreast of current thought and scholarship and easy to read' *The Times Literary Supplement*

This dictionary includes short biographies of over 1,200 painters, sculptors and engravers, with dates and information about the artists' careers, a note of galleries exhibiting their work and an estimate of their style. It also defines artistic movements, terms applied to periods and ideas and technical expressions and processes.

READ MORE IN PENGUIN

ART AND ARCHITECTURE

The Penguin Dictionary of Architecture
John Fleming, Hugh Honour and Nikolaus Pevsner

This wide-ranging dictionary includes entries on architectural terms, ornamentation, building materials, styles and movements, with over a hundred clear and detailed drawings. 'Immensely useful, succinct and judicious ... this is a book rich in accurate fact and accumulated wisdom' *The Times Literary Supplement*

Style and Civilization

These eight beautifully illustrated volumes interpret the major styles in European art – from the Byzantine era and the Renaissance to Romanticism and Realism – in the broadest context of the civilization and thought of their times. 'One of the most admirable ventures in British scholarly publishing' *The Times*

Michelangelo: A Biography George Bull

'The final picture of Michelangelo the man is suitably three-dimensional and constructed entirely of evidence as strong as Tuscan marble' *Sunday Telegraph*. 'An impressive number of the observations we are treated to, both in matters of fact and in interpretation, are taking their first bows beyond the confines of the world of the learned journal' *The Times*

Values of Art Malcolm Budd

'Budd is a first-rate thinker ... He brings to aesthetics formidable gifts of precision, far-sightedness and argument, together with a wide philosophical knowledge and a sincere belief in the importance of art' *The Times*